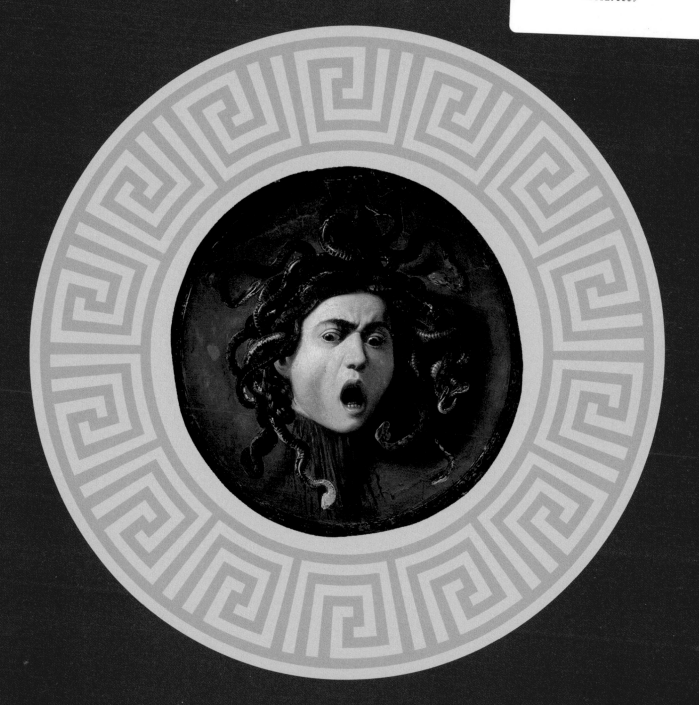

GREEK & ROMAN MYTHOLOGY

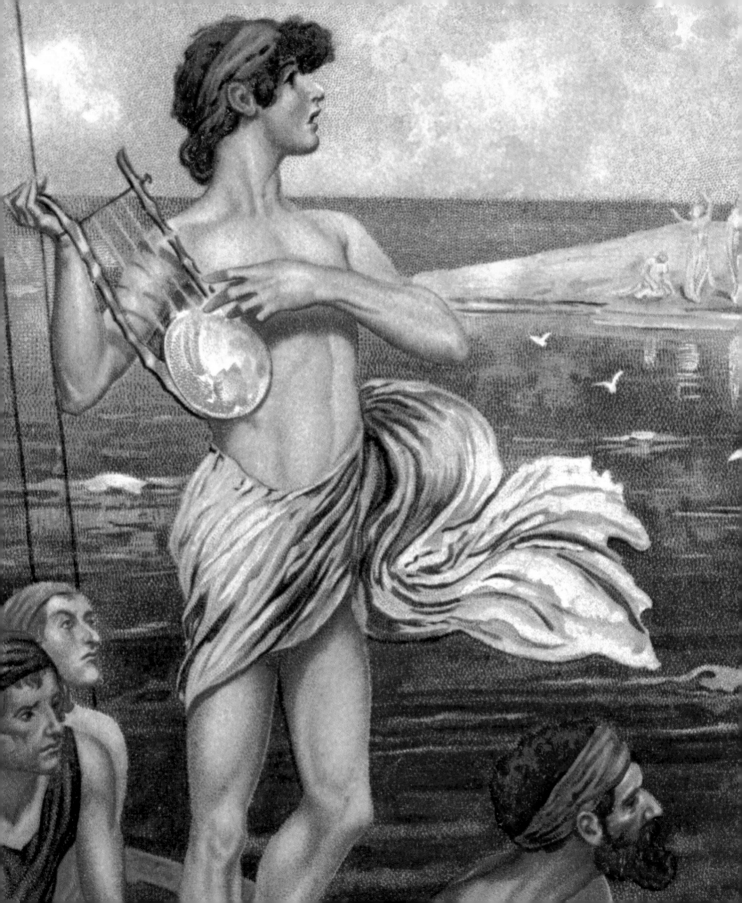

GREEK & ROMAN MYTHOLOGY

DOVERPICTURA

DOVER PUBLICATIONS, INC. | Mineola, New York

By Alan Weller.
Designed by Joel Waldrep.

Greek & Roman Mythology is a new work, first published by Dover Publications, Inc., in 2008.

The CD-ROM file names correspond to the images in the book. All of the artwork stored on the CD-ROM can be imported directly into a wide range of design and word-processing programs on either Windows or Macintosh platforms. No further installation is necessary.

ISBN 10: 0-486-99028-1
ISBN 13: 978-0-486-99028-6
Manufactured in the United States of America
Dover Publications, Inc., 31 East 2nd Street, Mineola, NY 11501
www.doverpublications.com

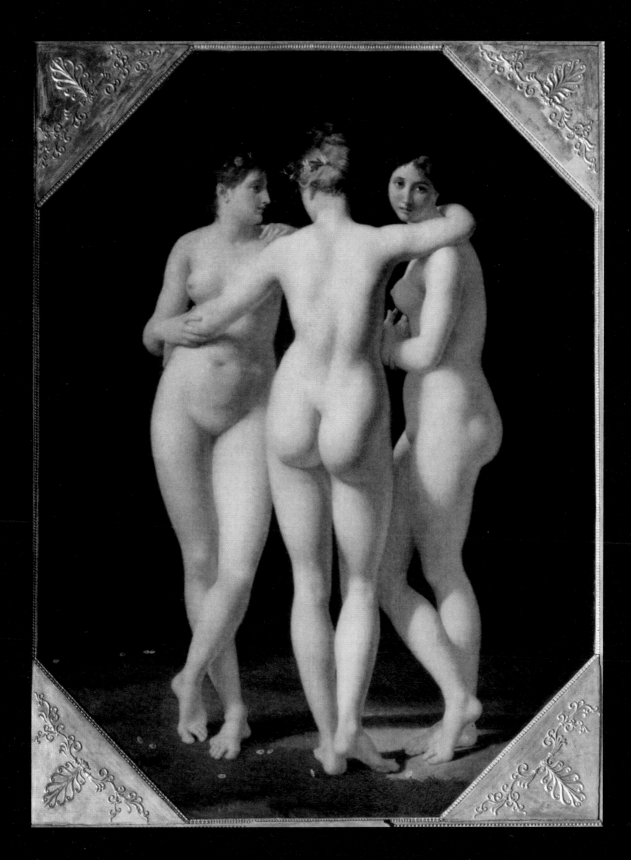

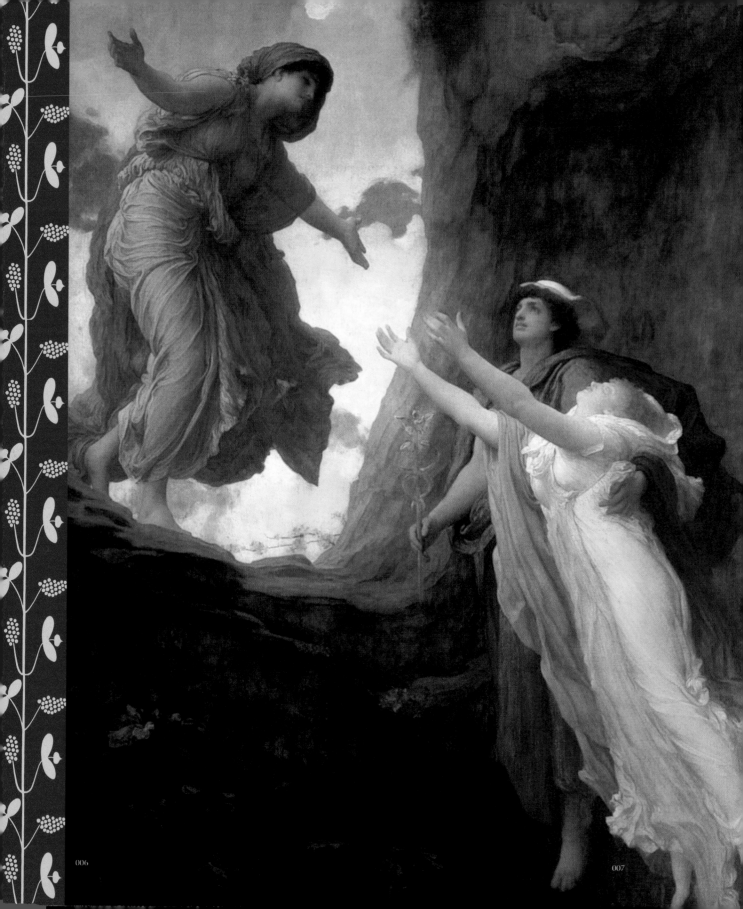

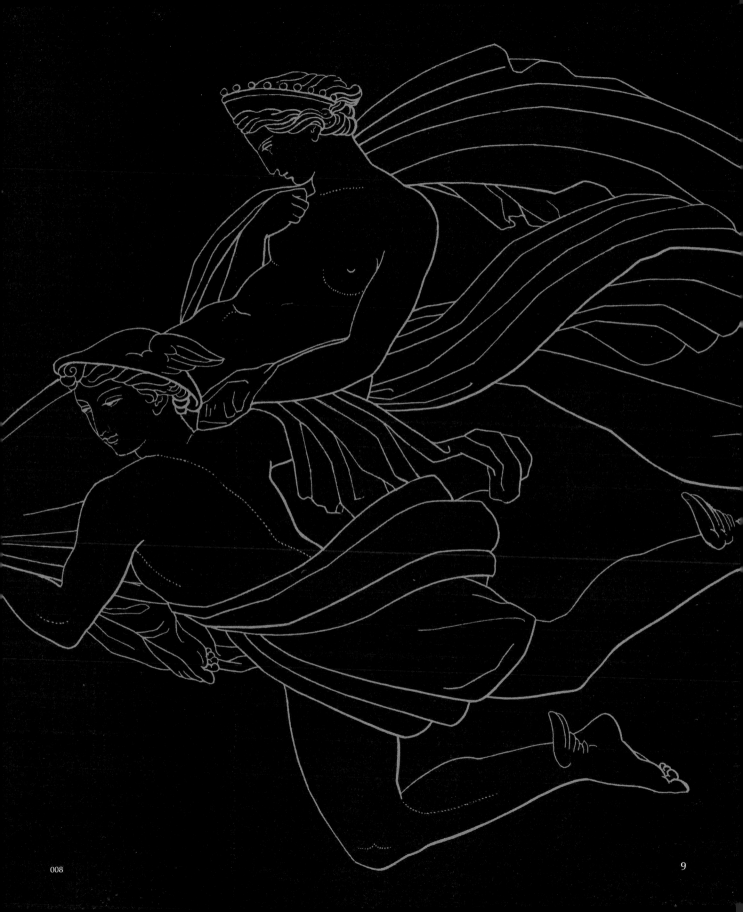

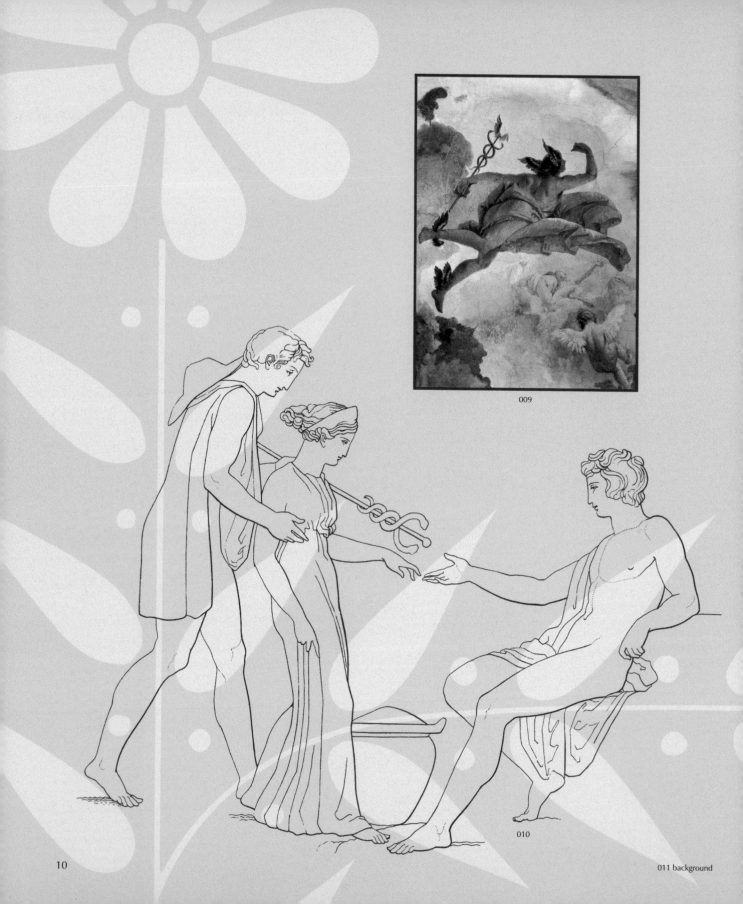

009

010

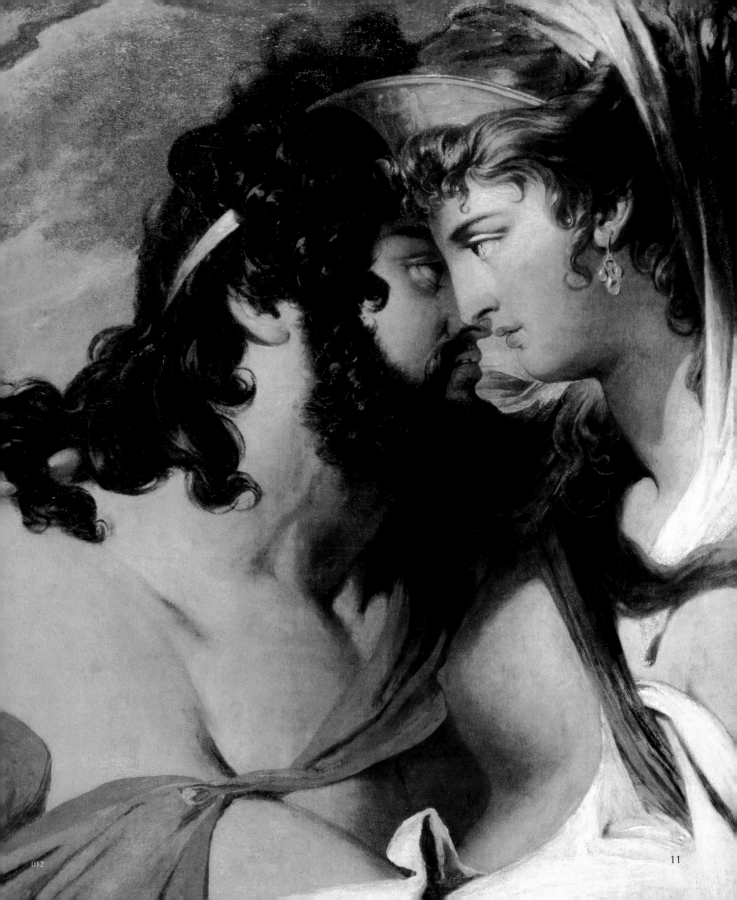

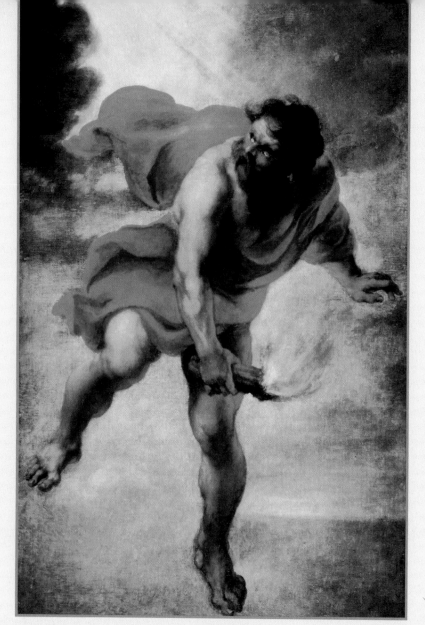

013

014 background

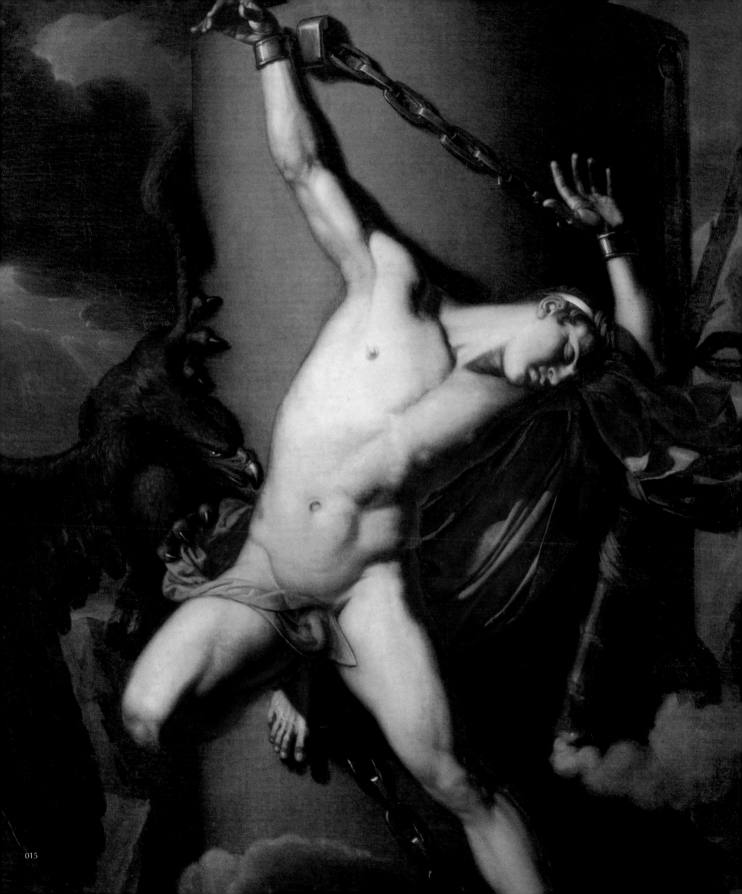

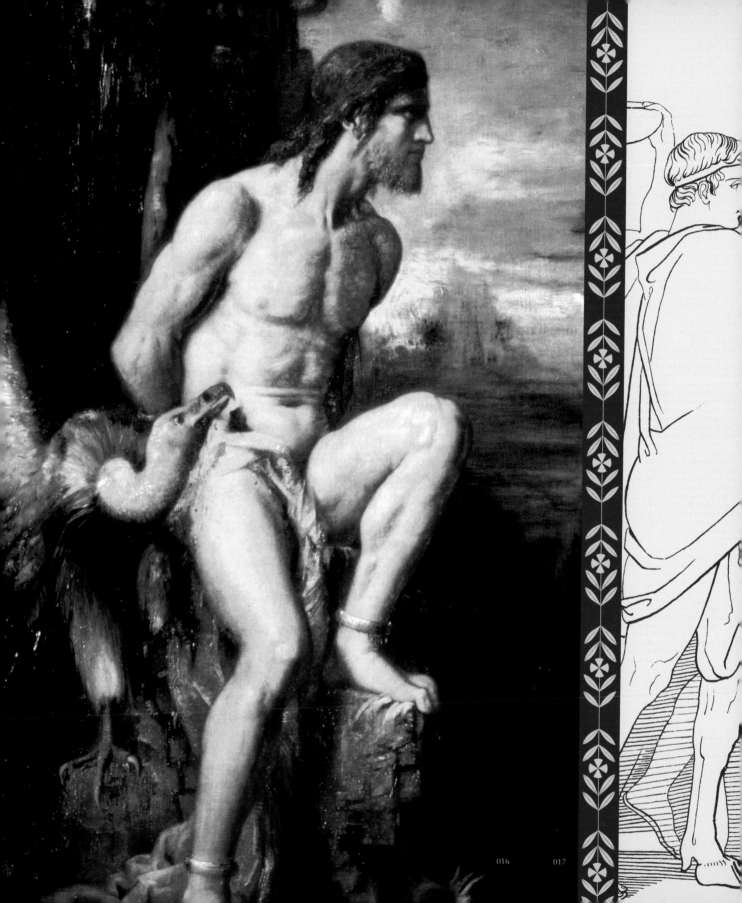

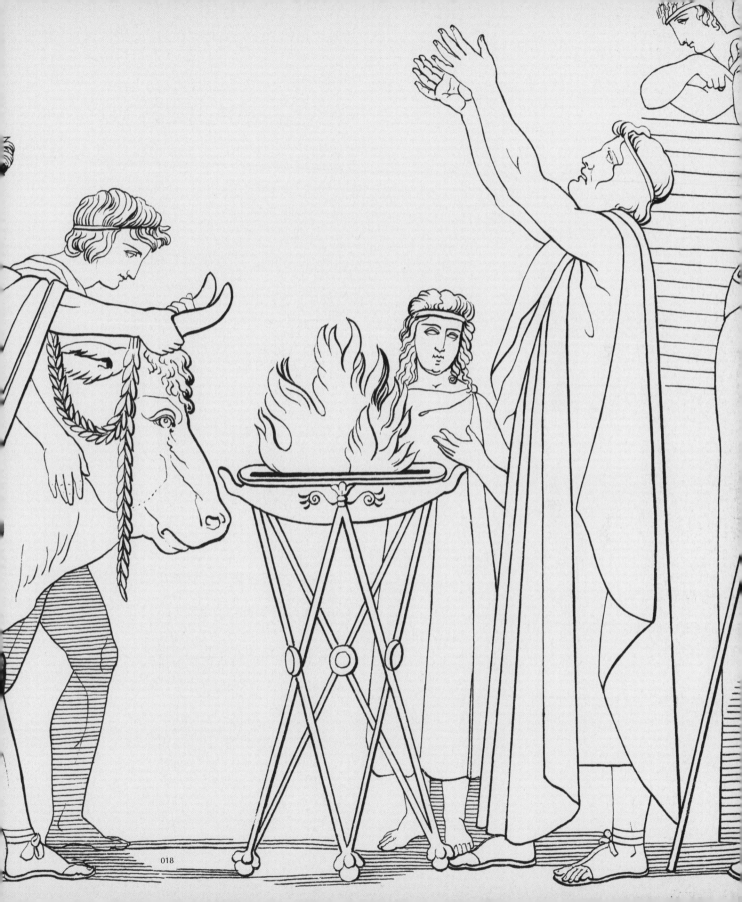

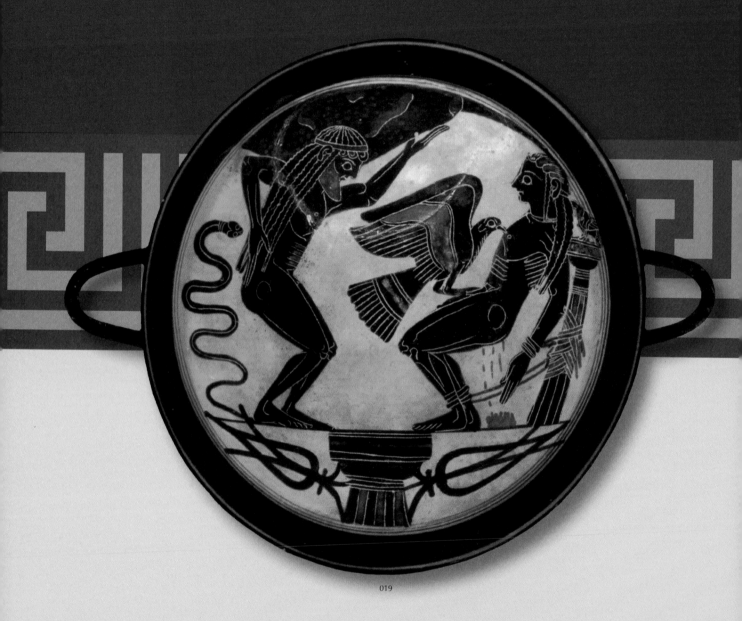

019

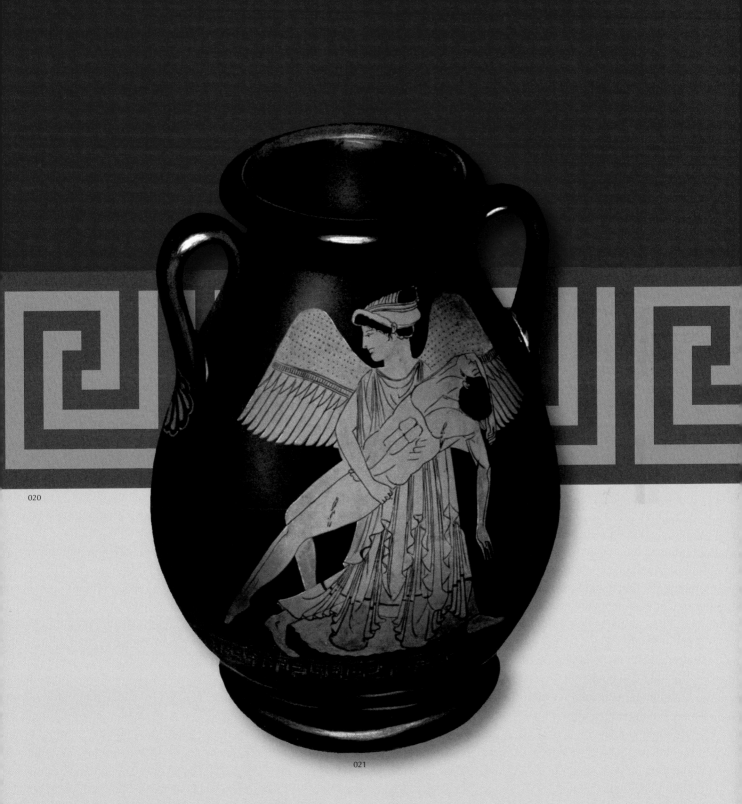

020

021

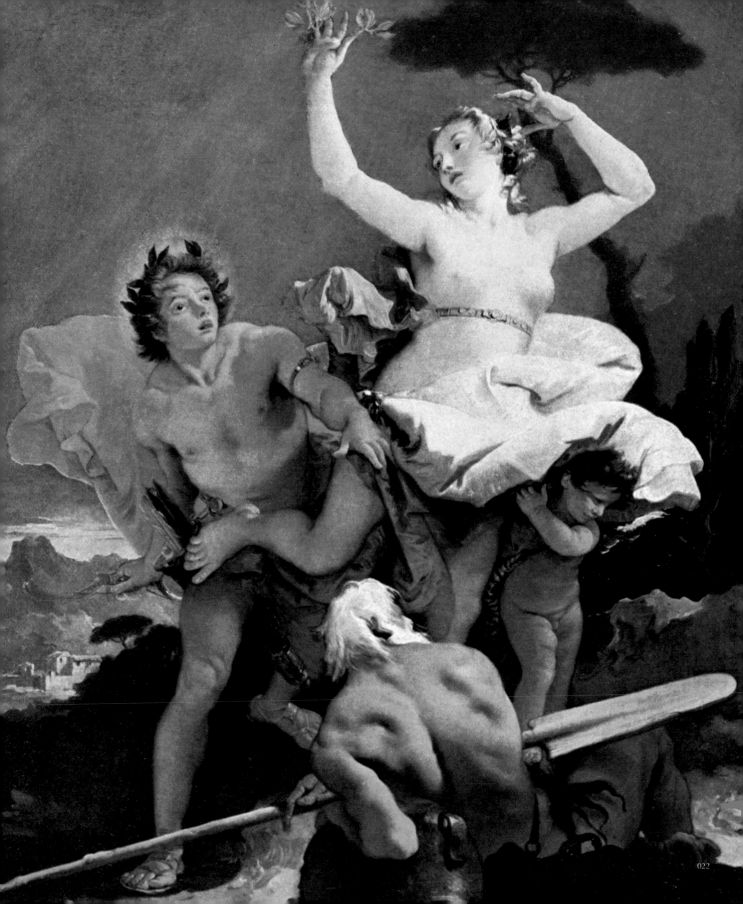

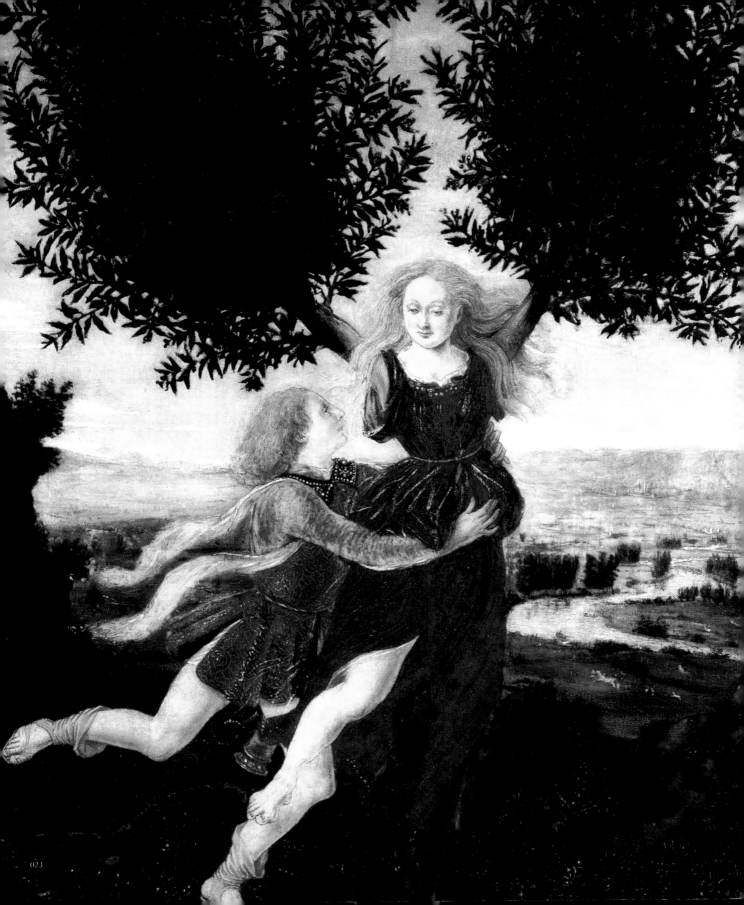

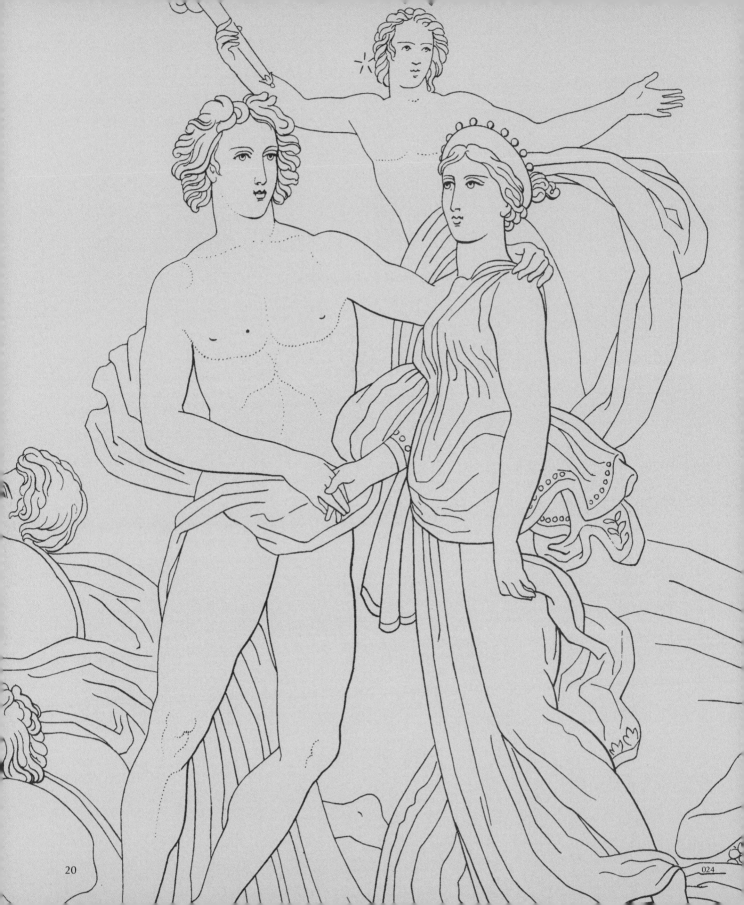

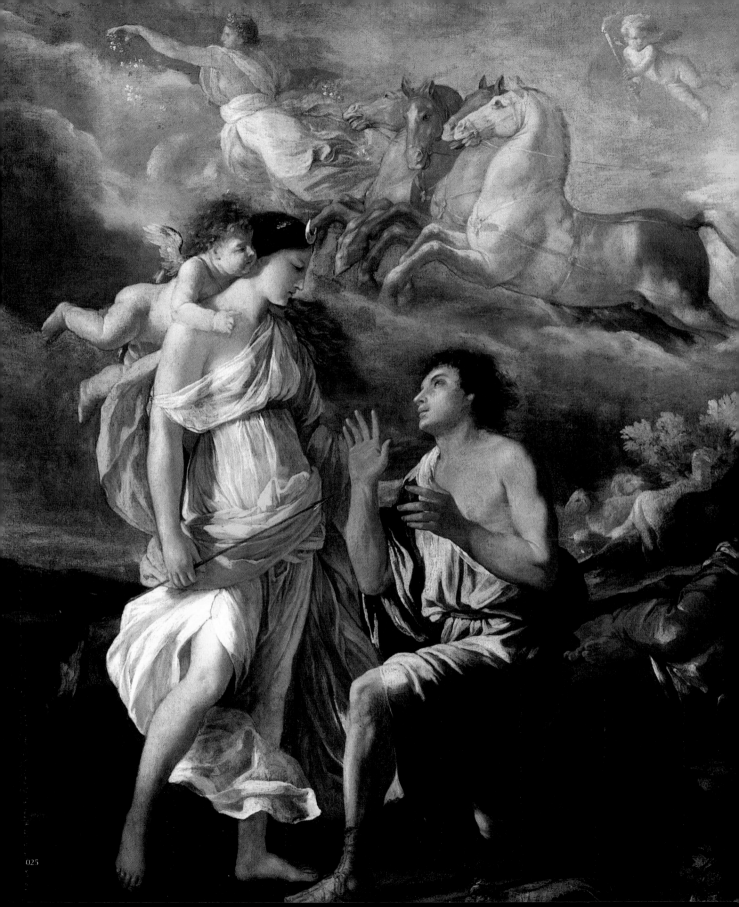

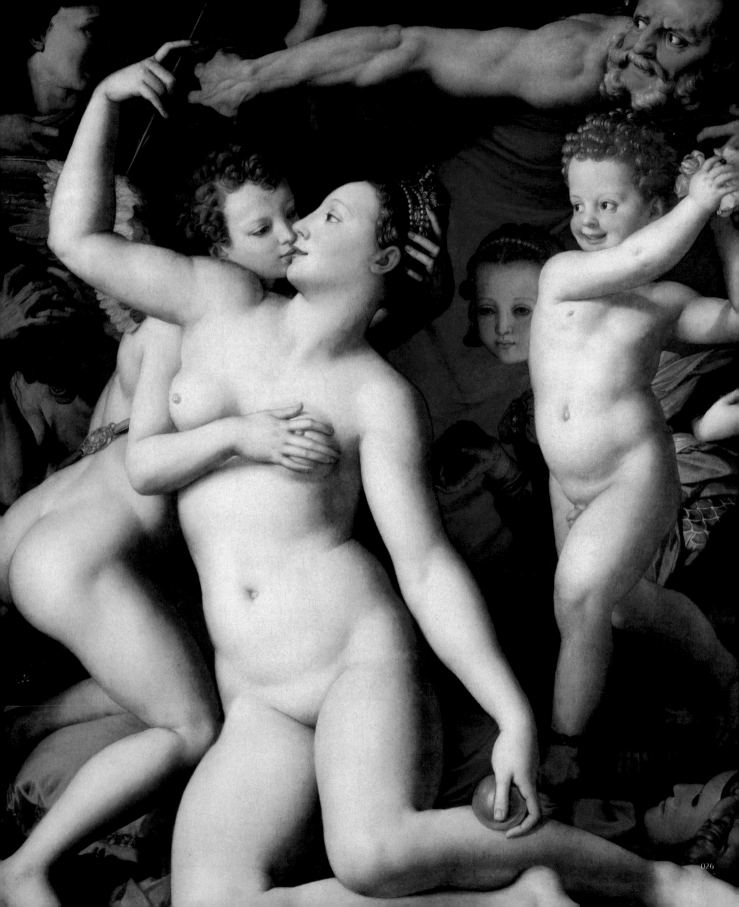

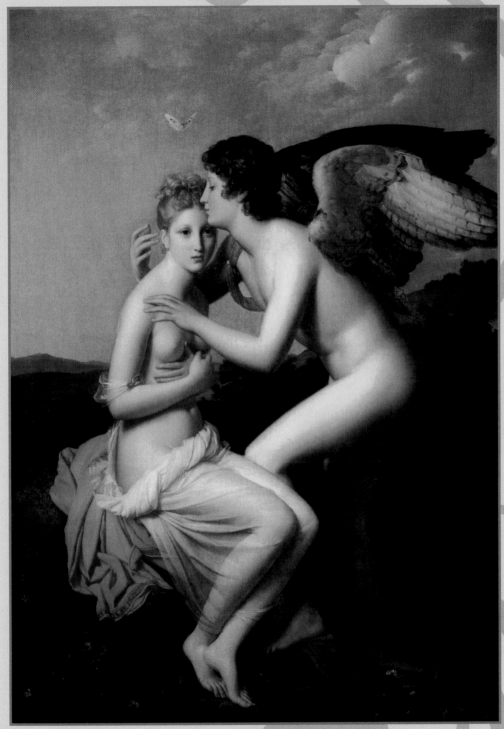

027

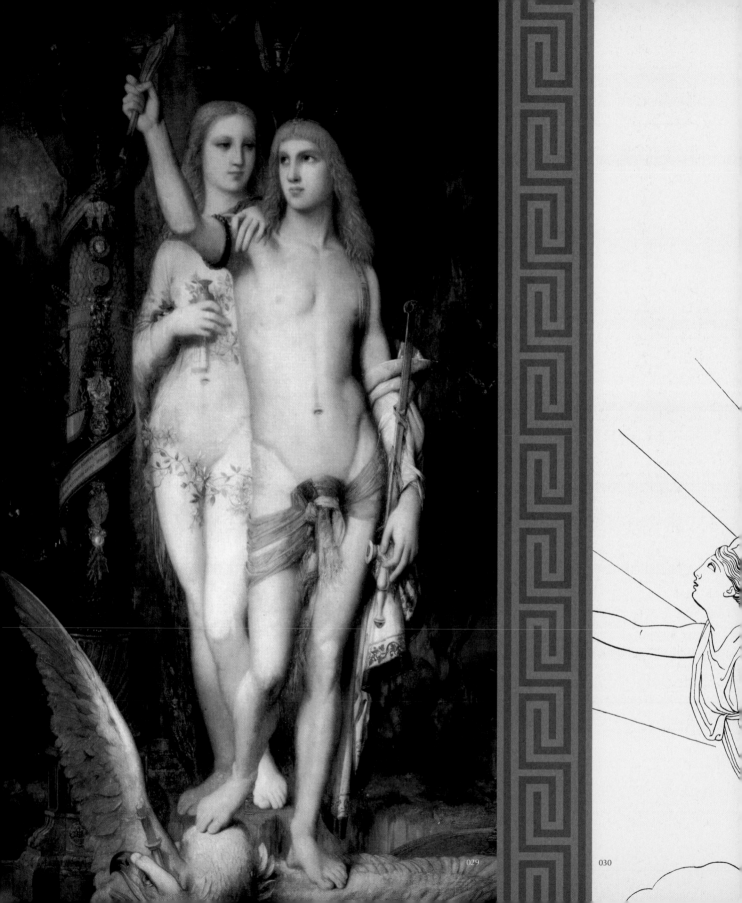

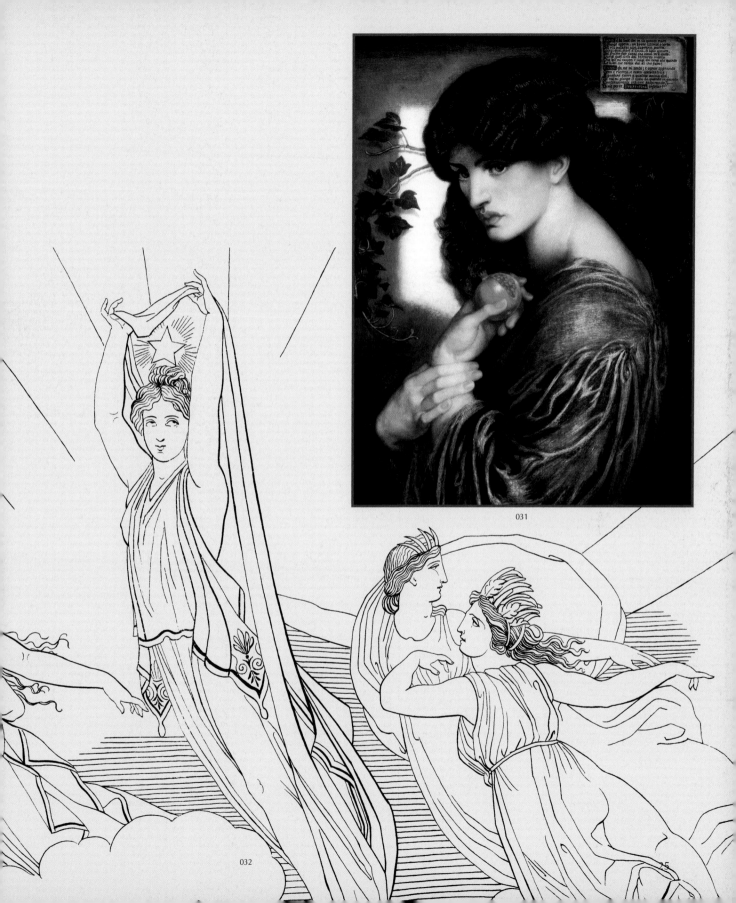

031

032

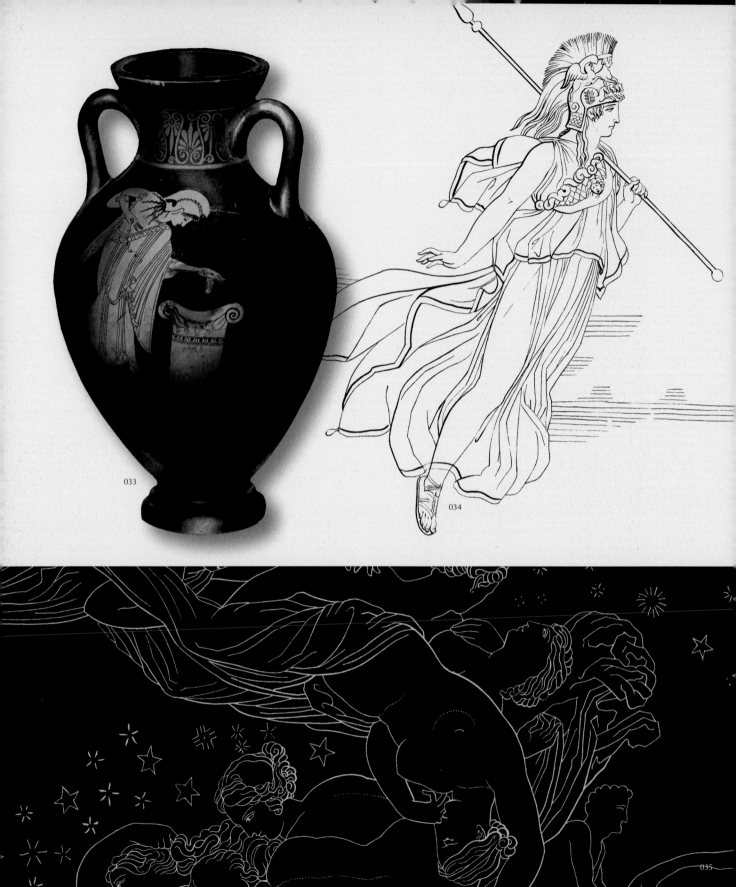

033

034

035

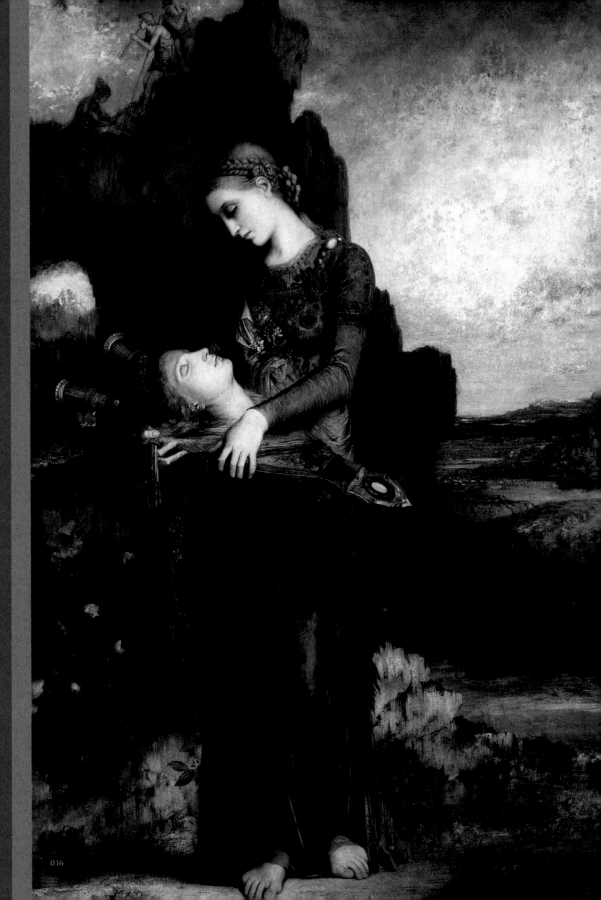

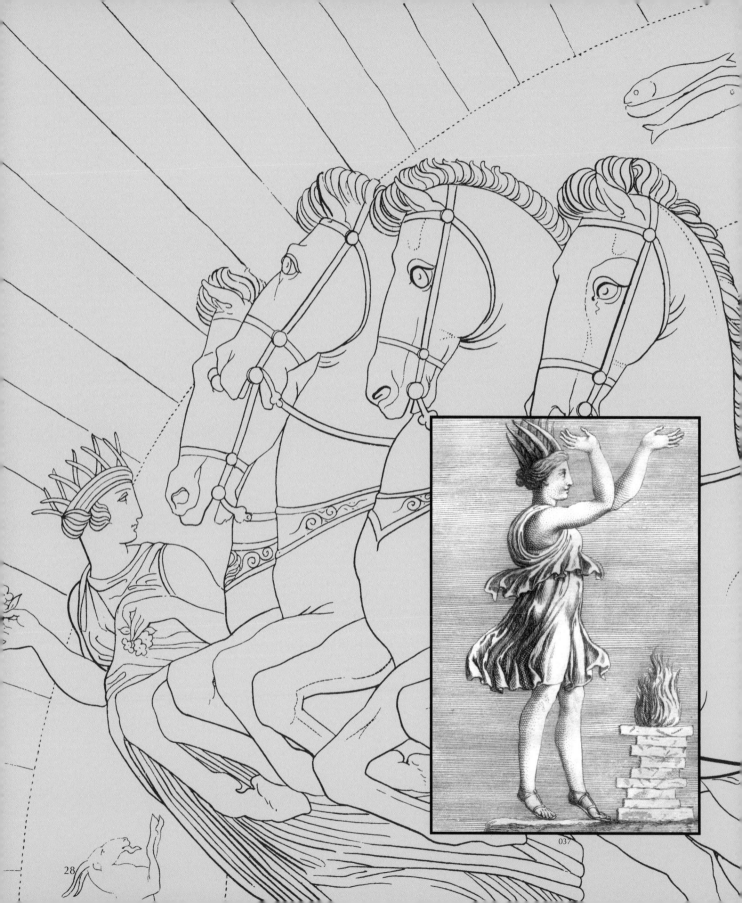

037

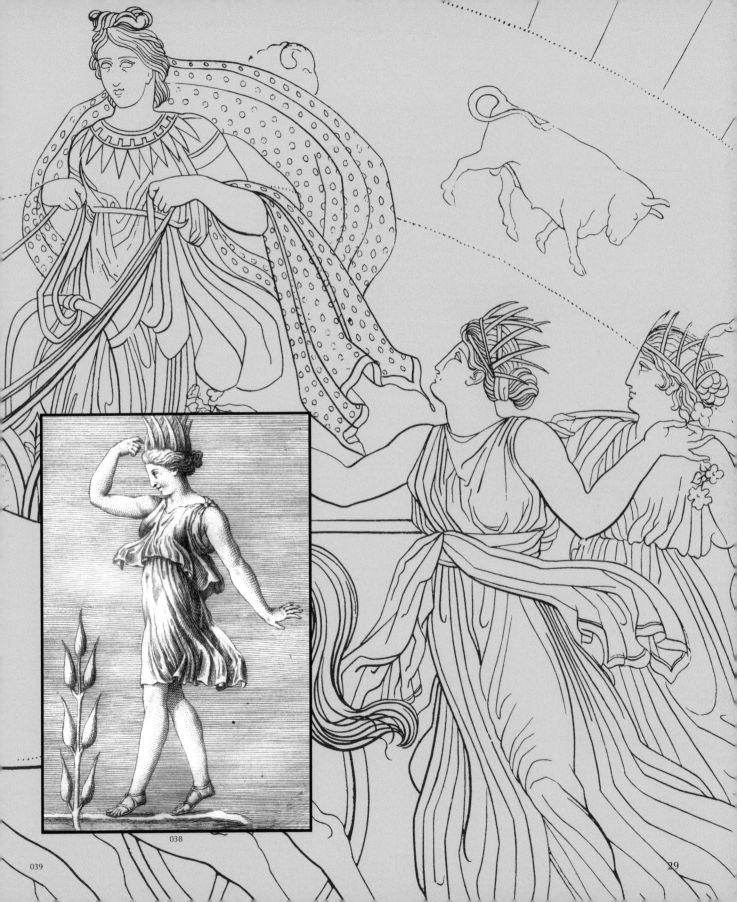

038

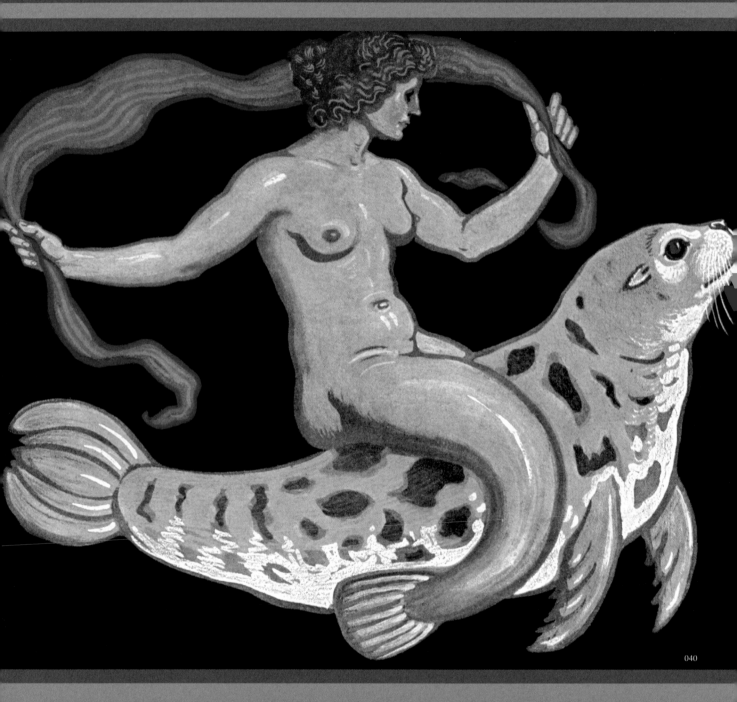

040

041

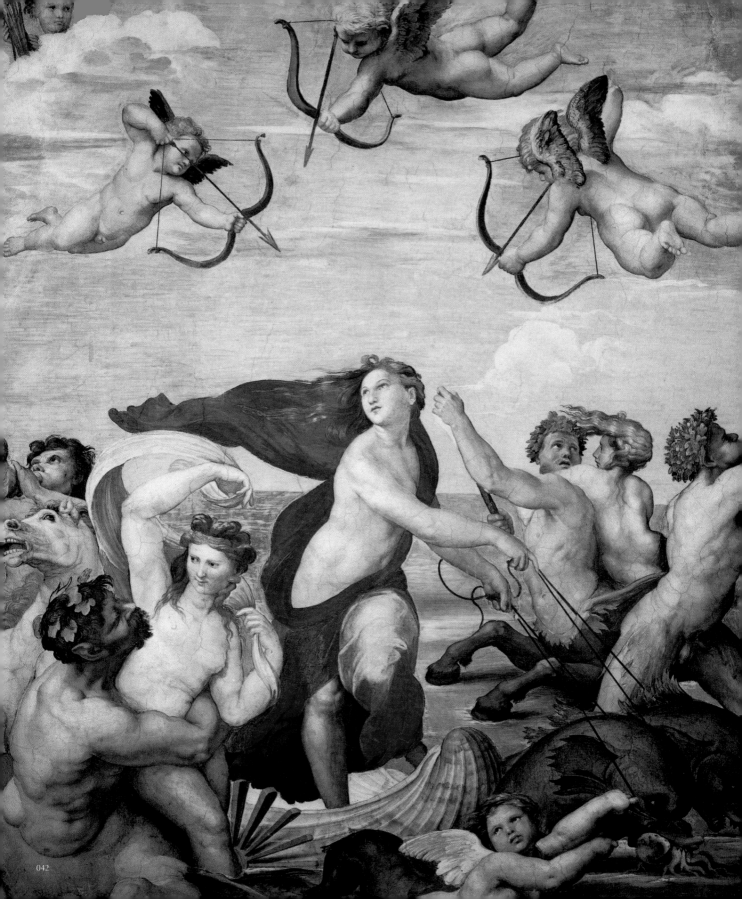

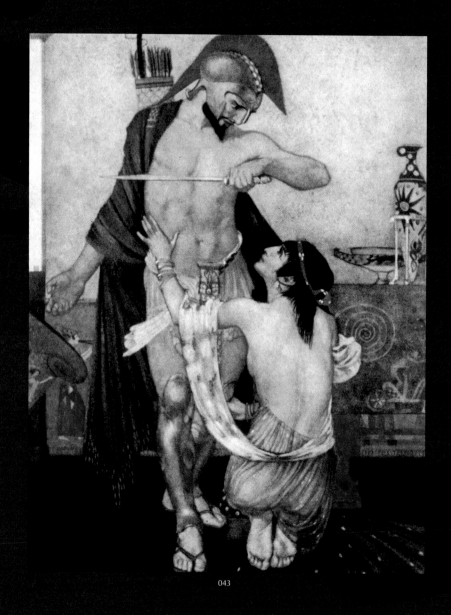

043

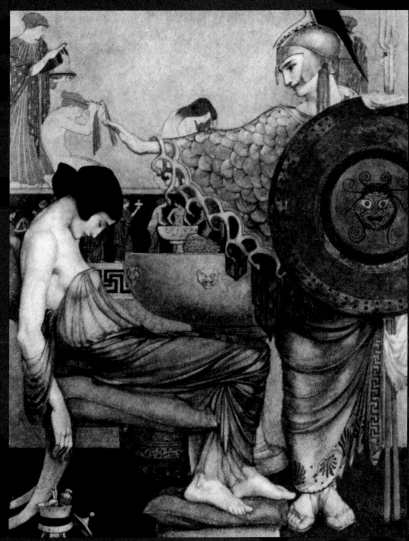

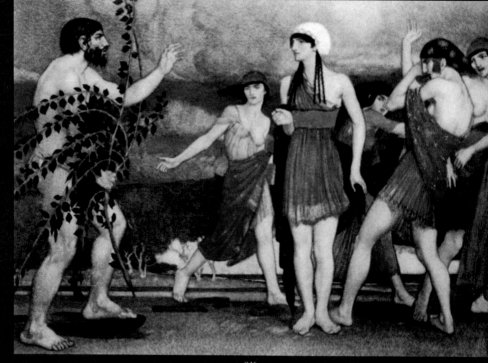

046

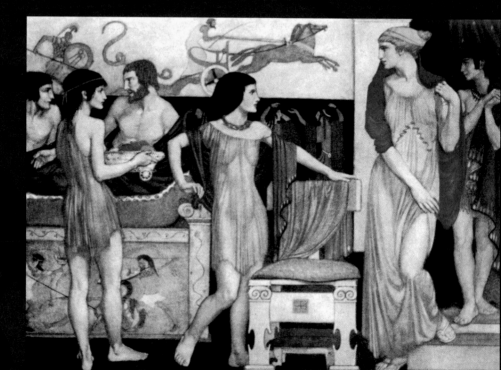

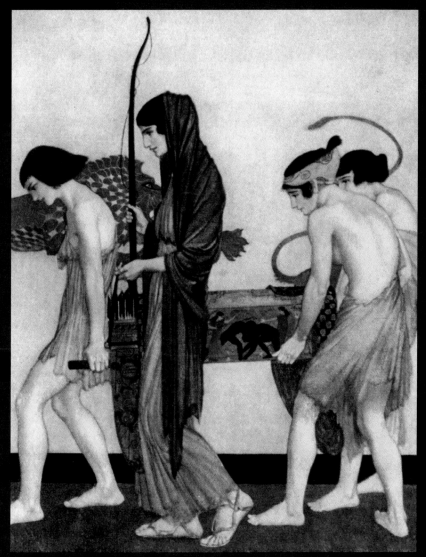

048

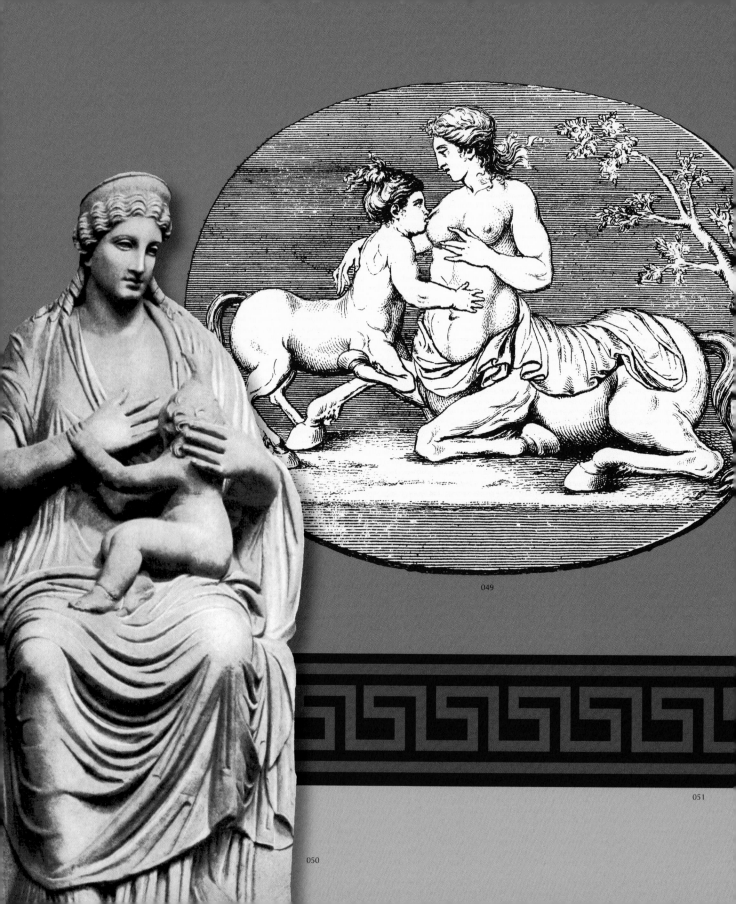

049

050

051

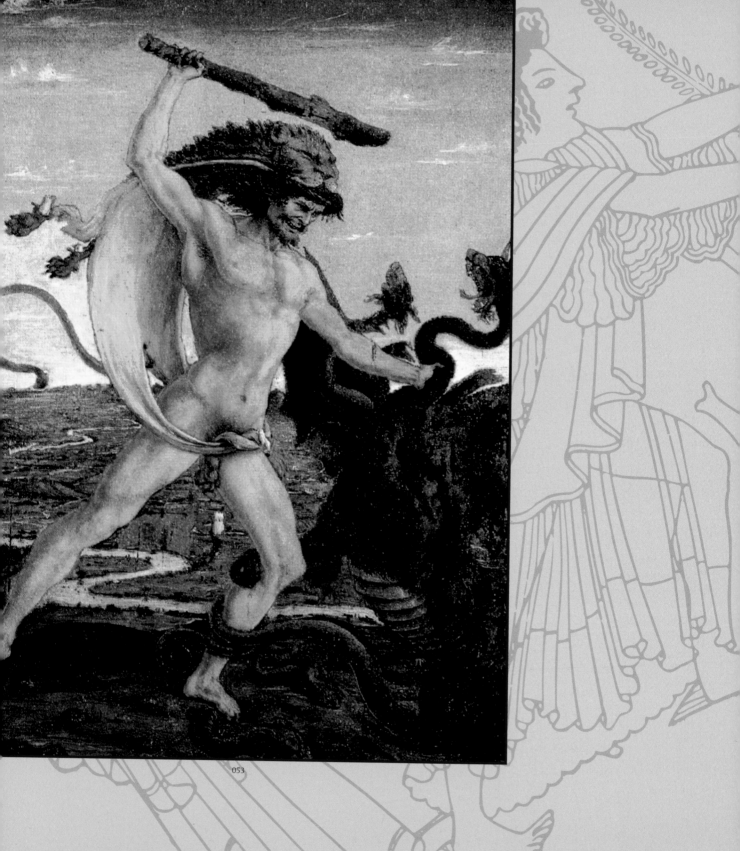

053

054 background

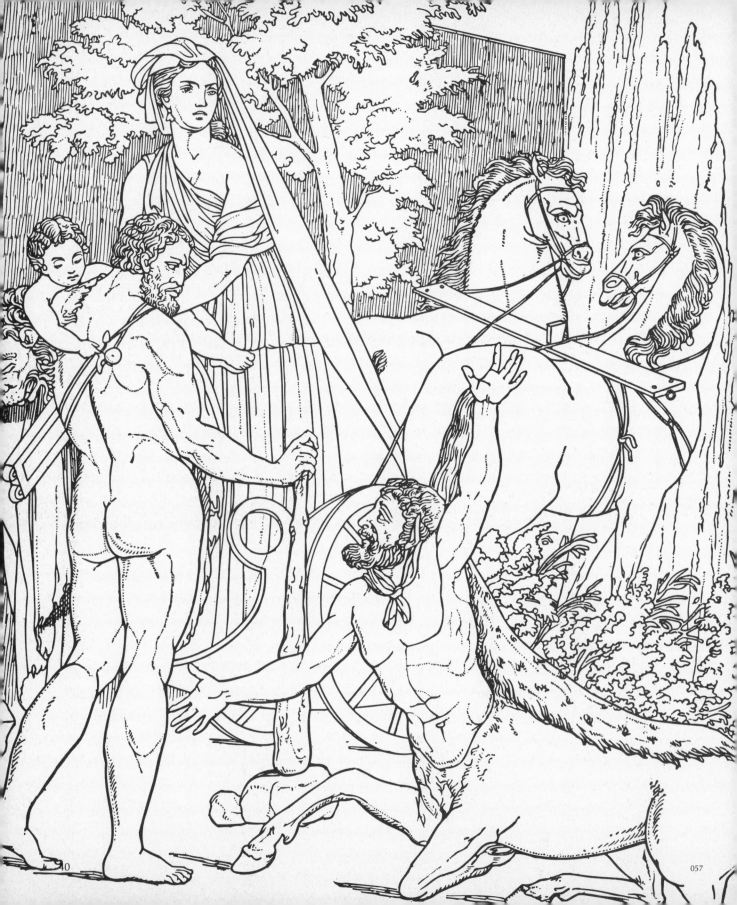

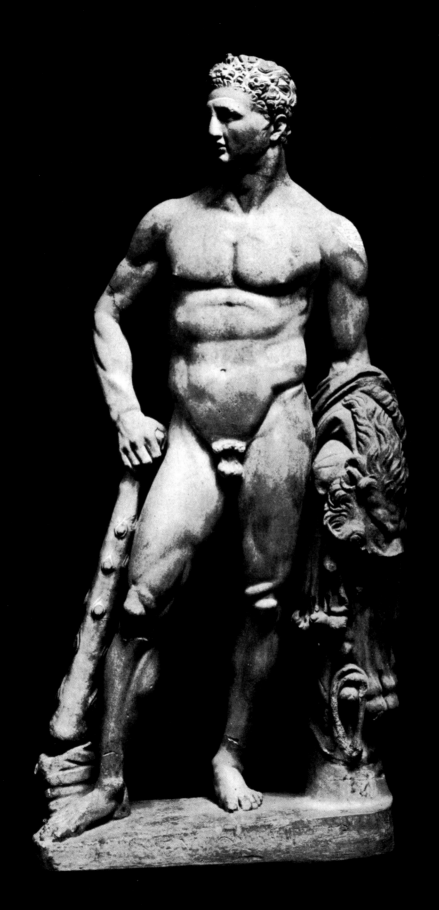

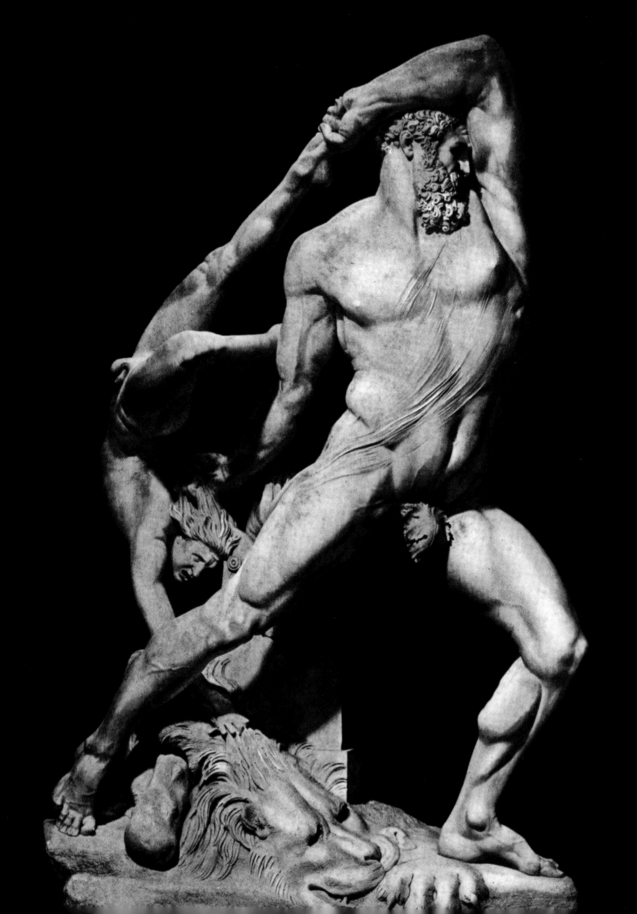

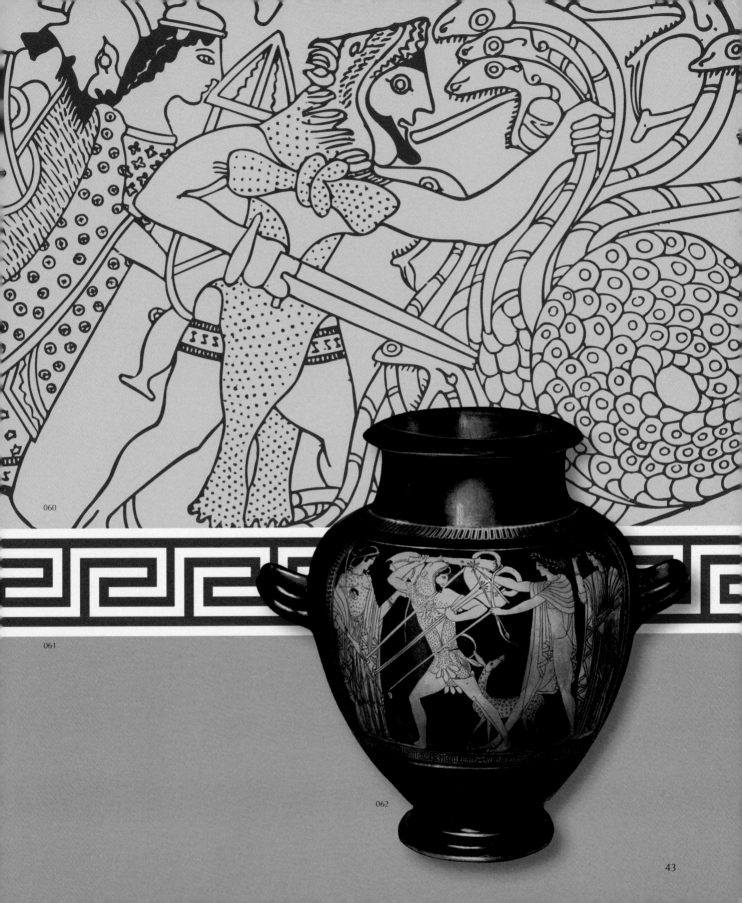

060

061

062

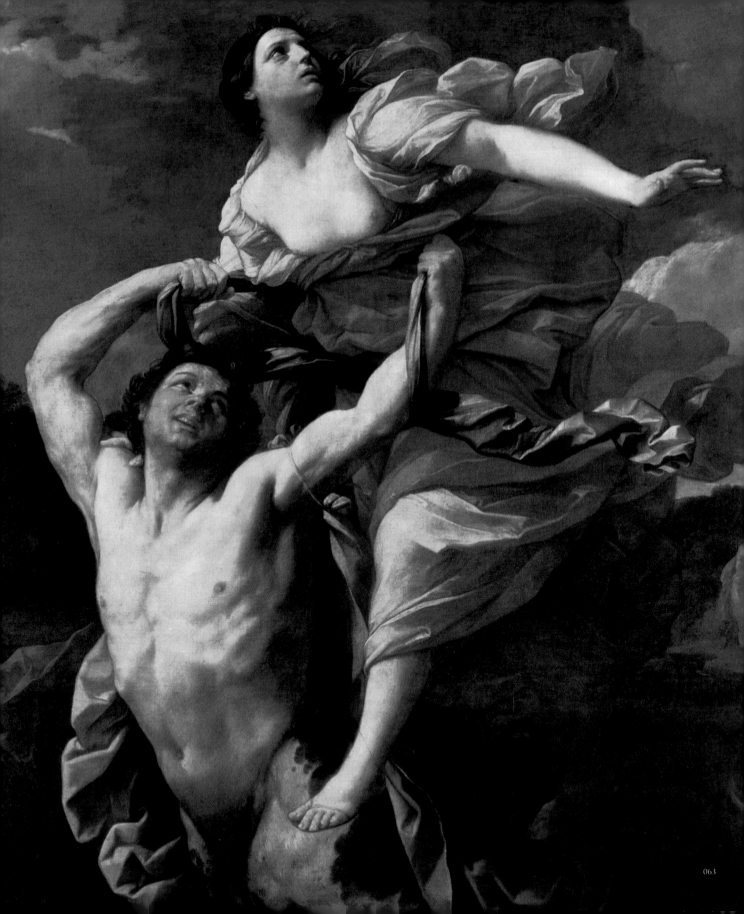

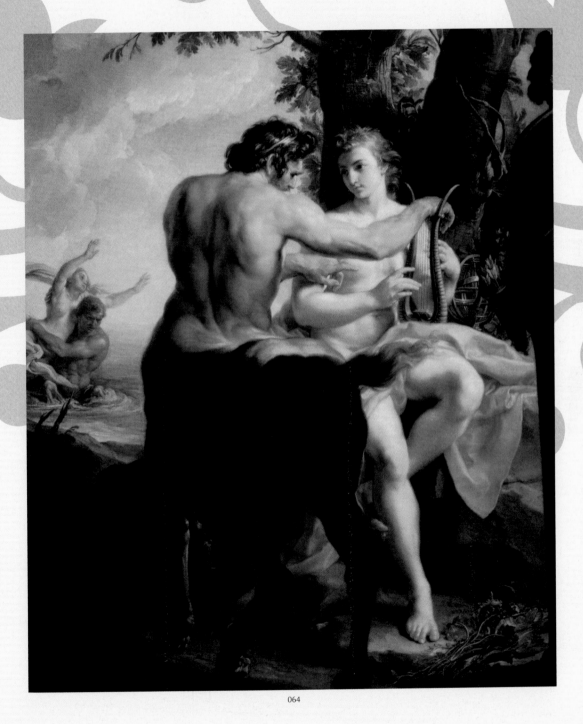

064

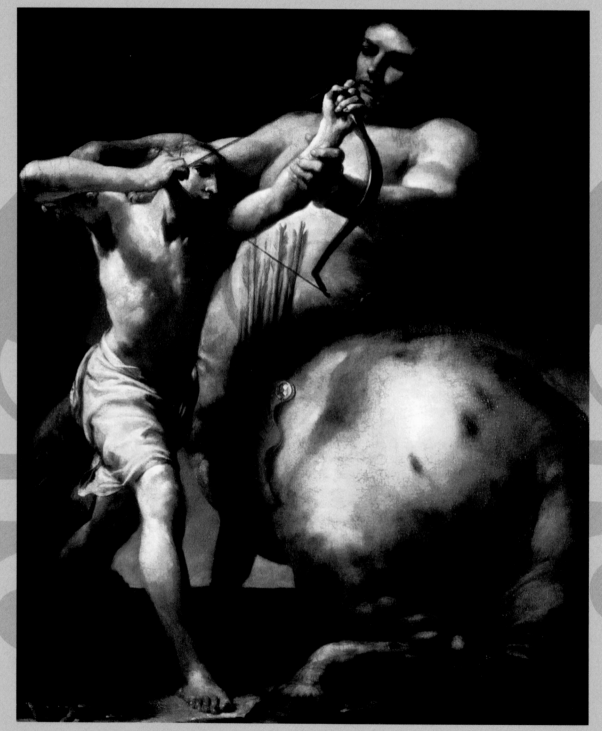

066

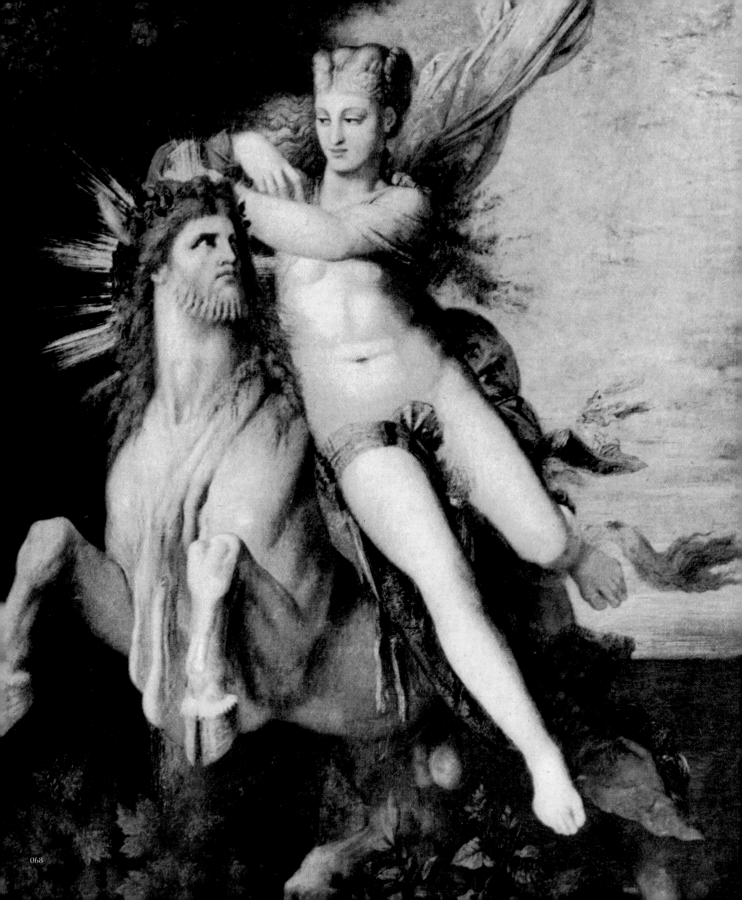

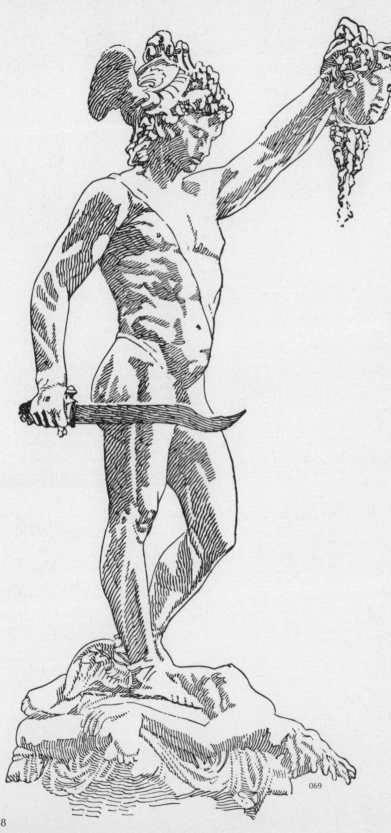

069

070

071

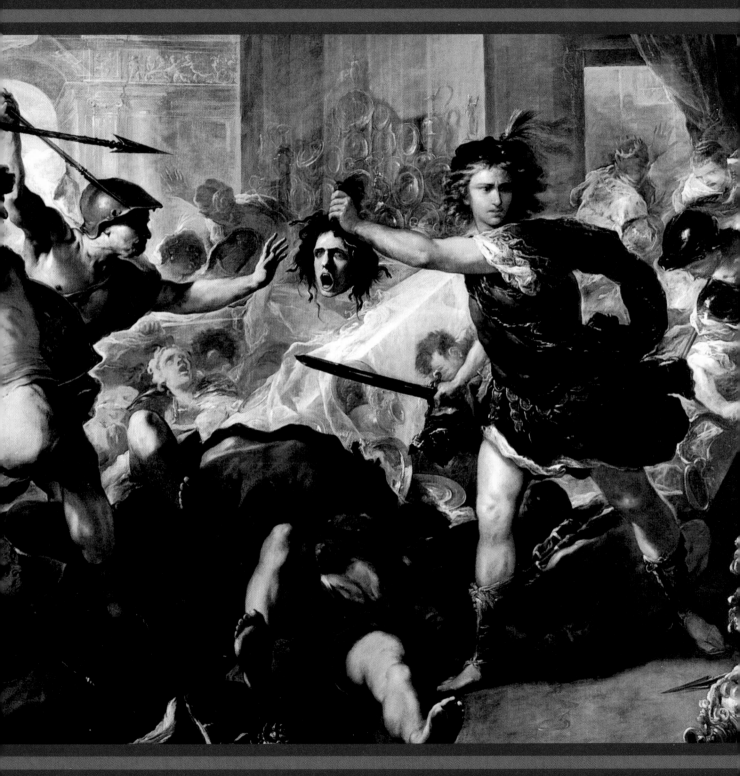

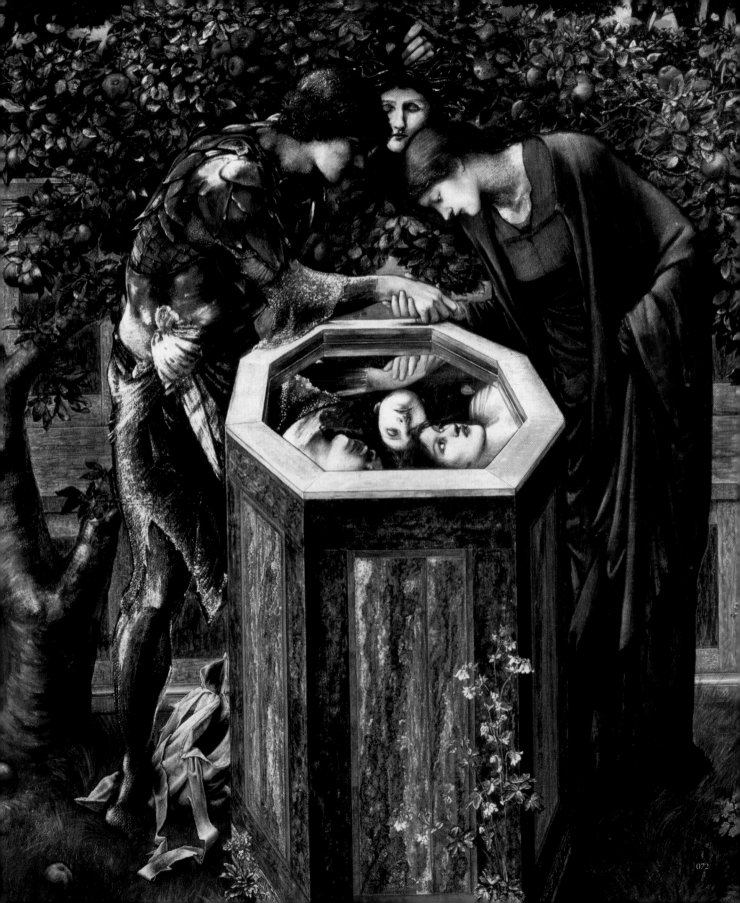

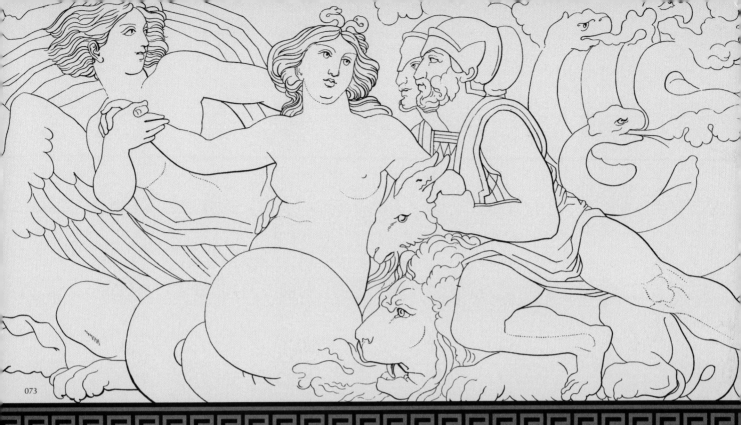

073

074

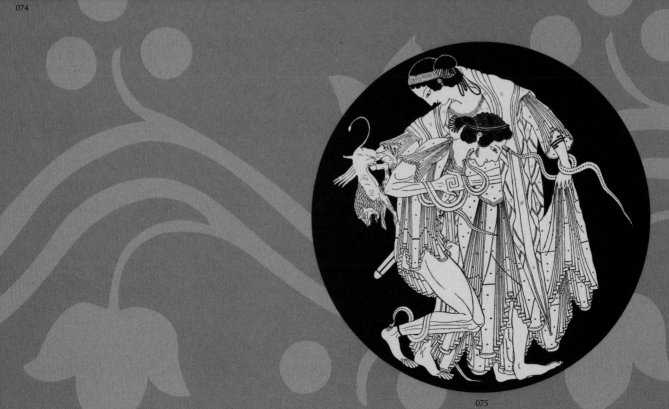

075

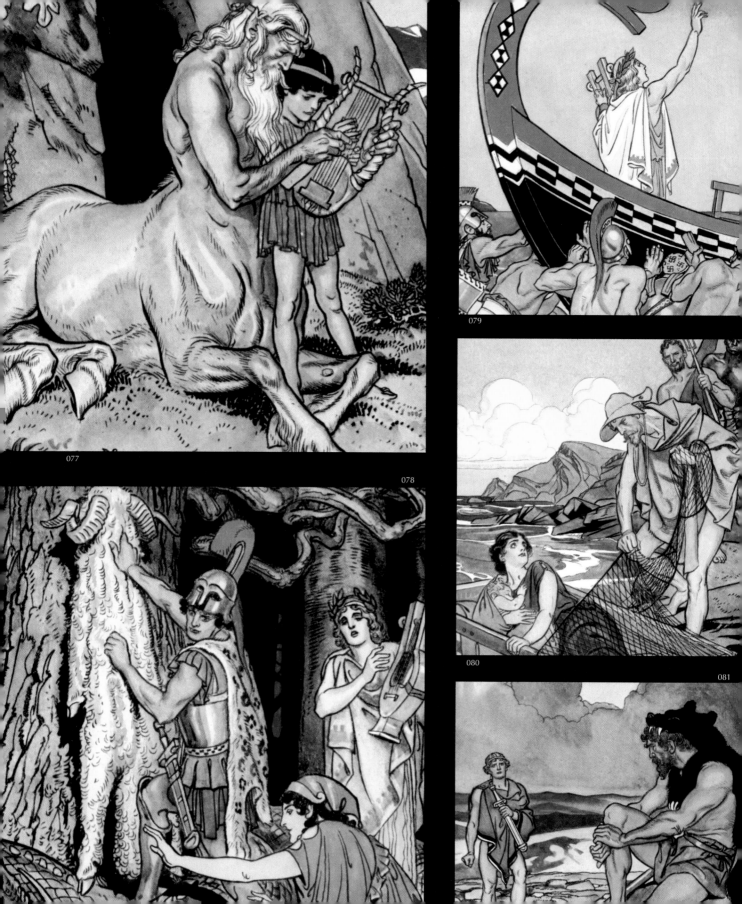

077

078

079

080

081

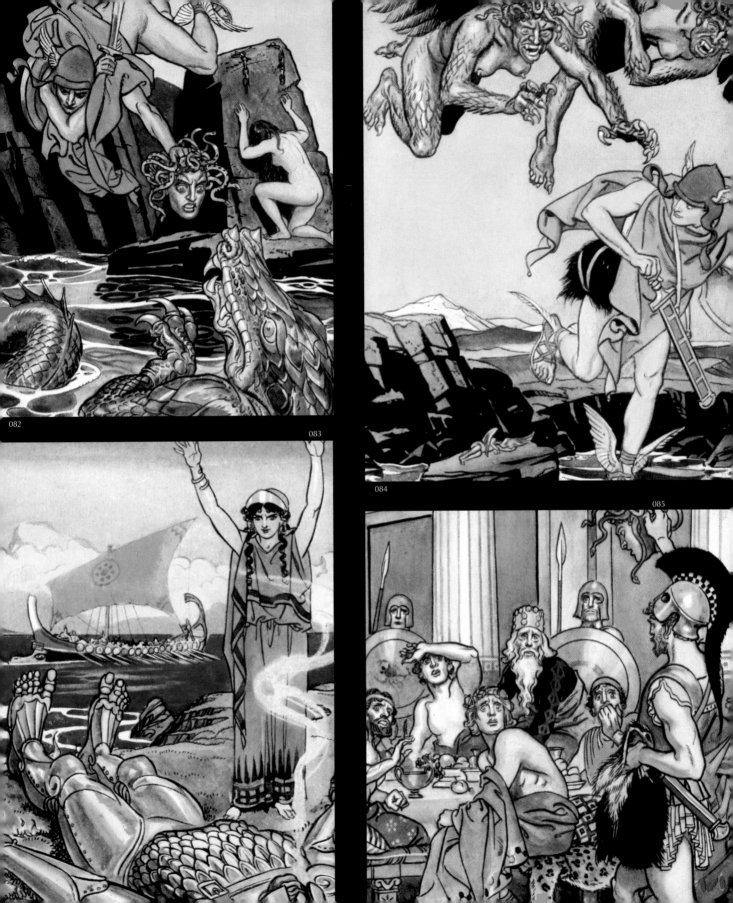

082

083

084

085

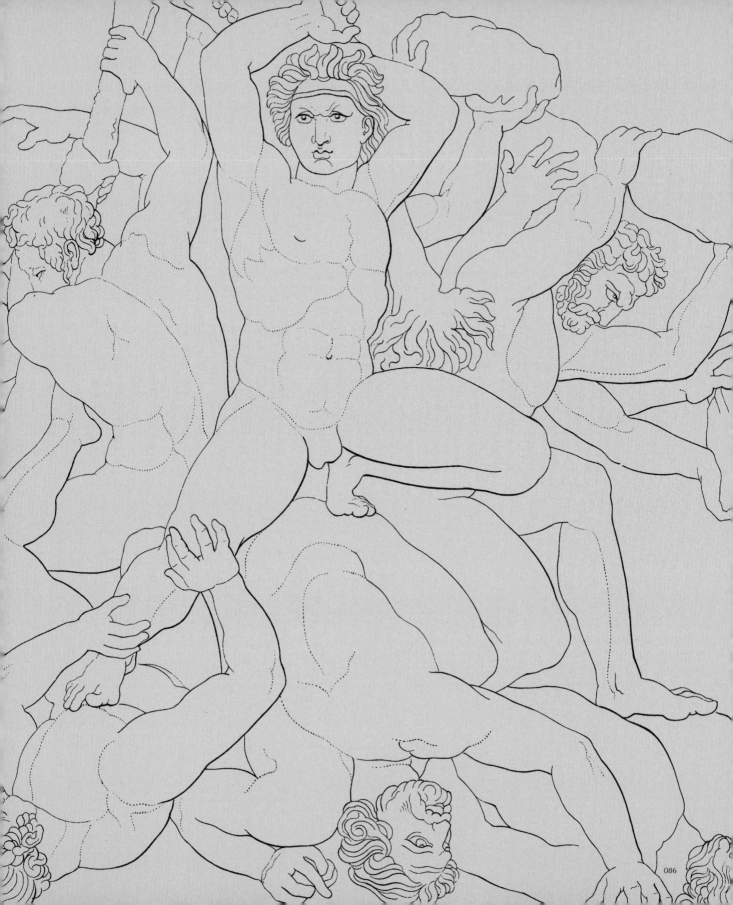

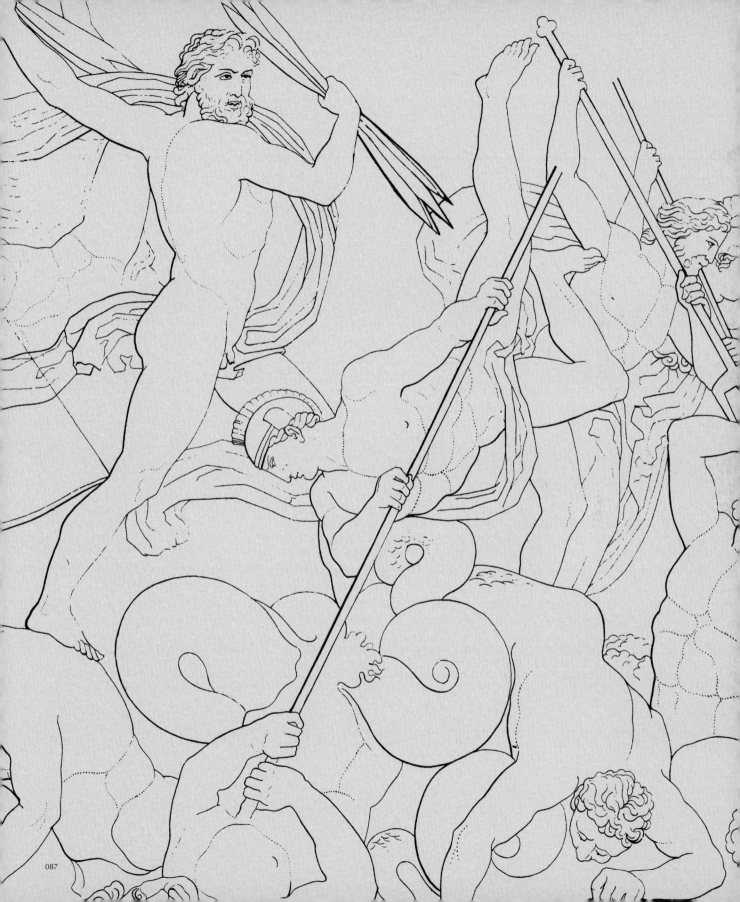

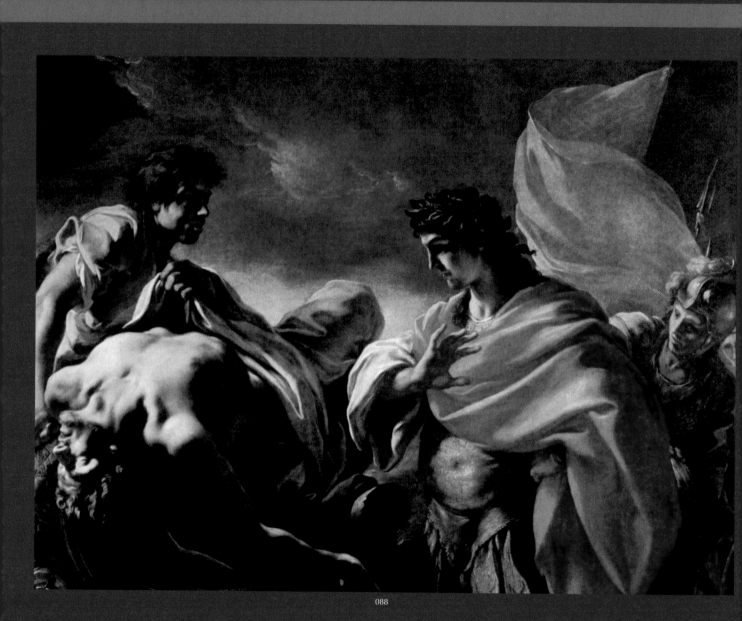

088

071

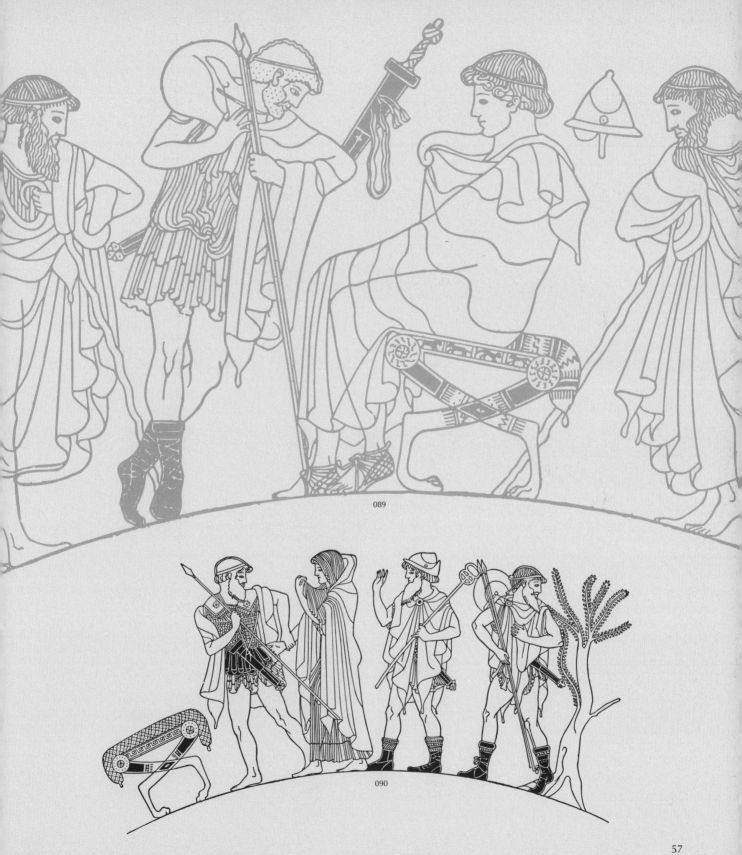

089

090

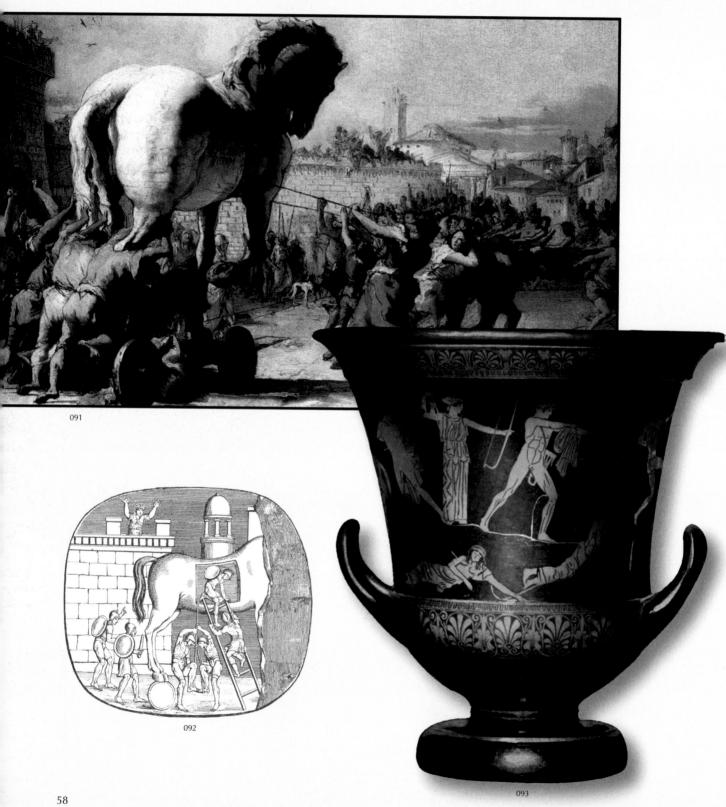

091

092

093

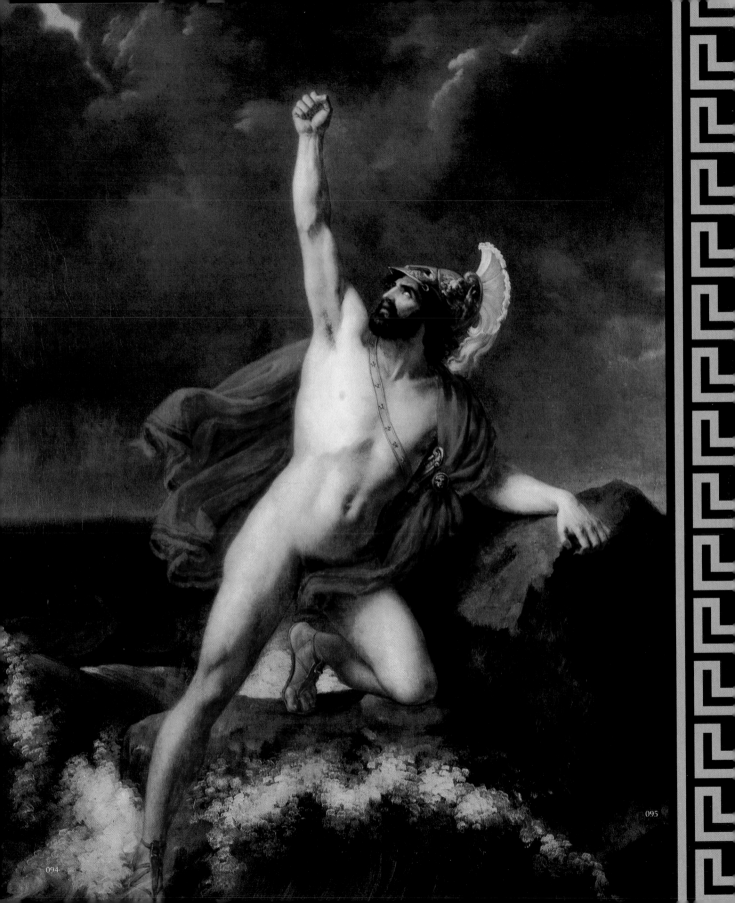

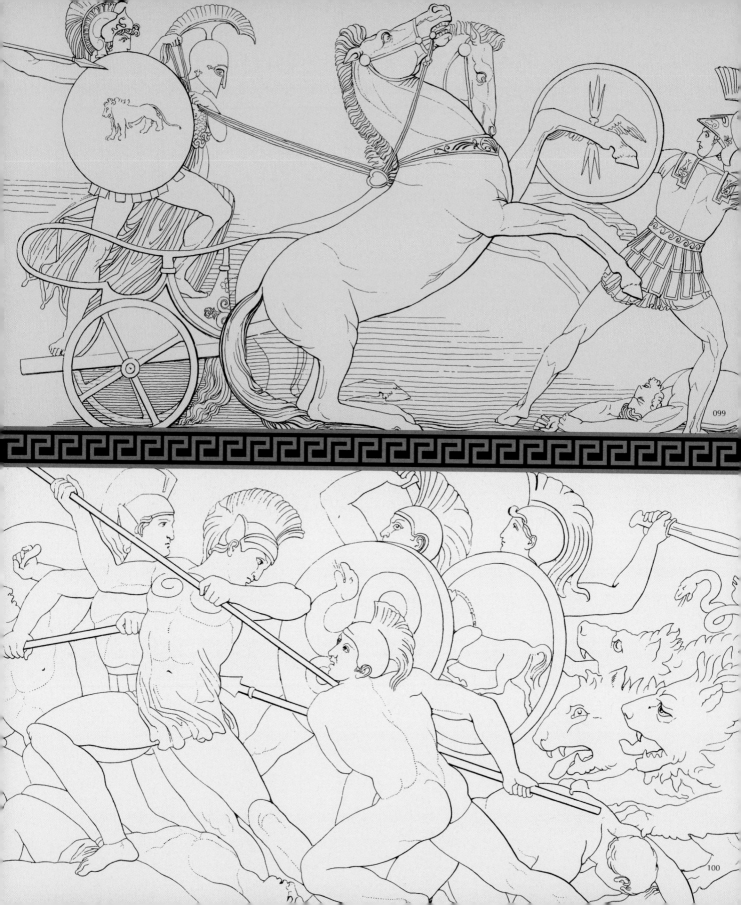

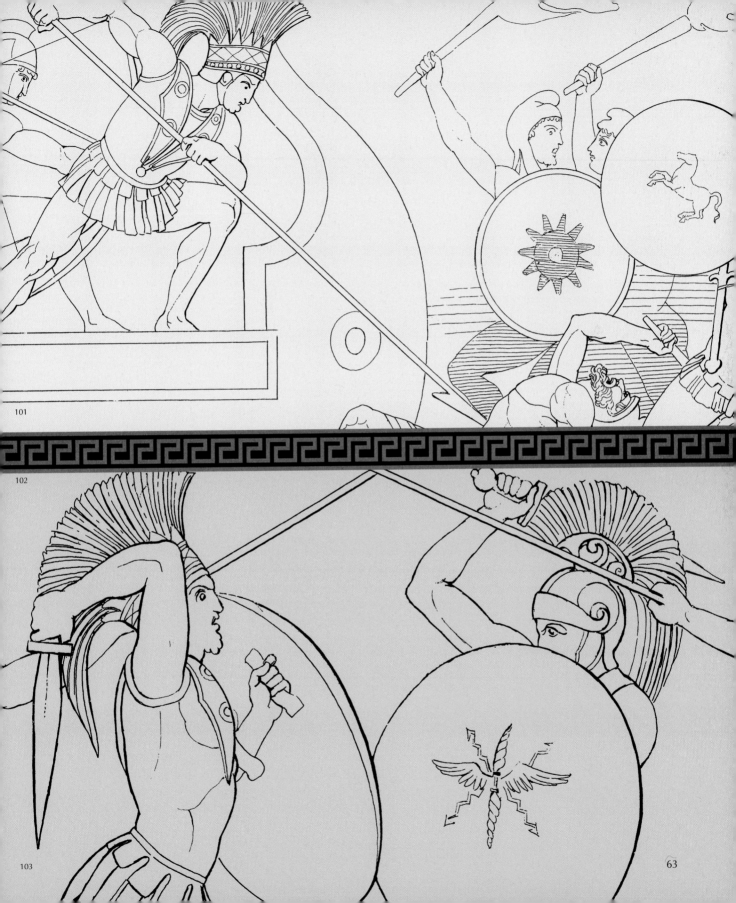

101

102

103

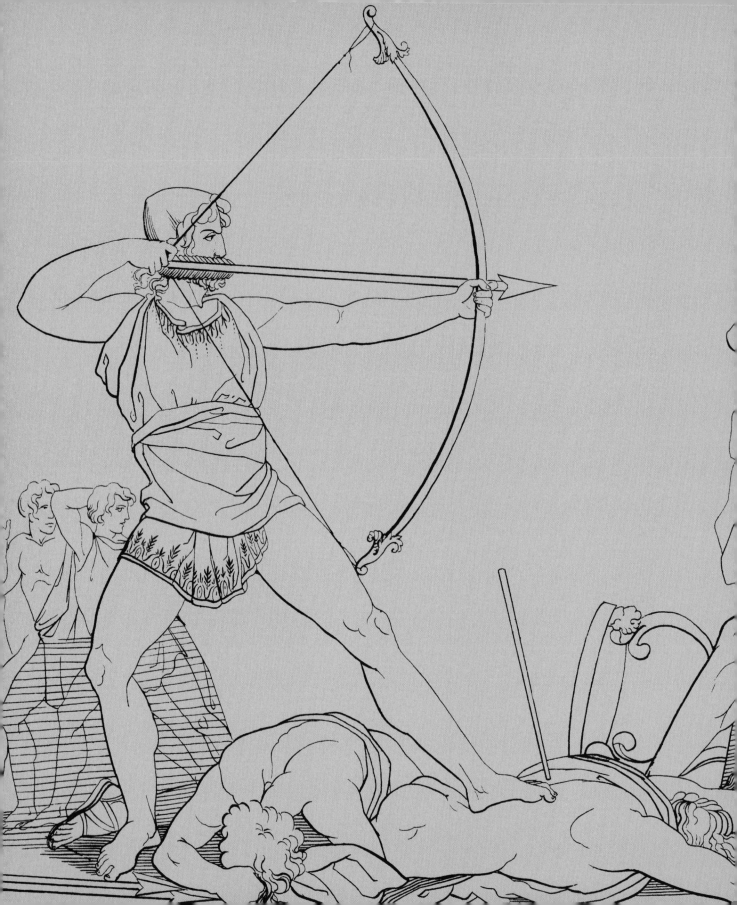

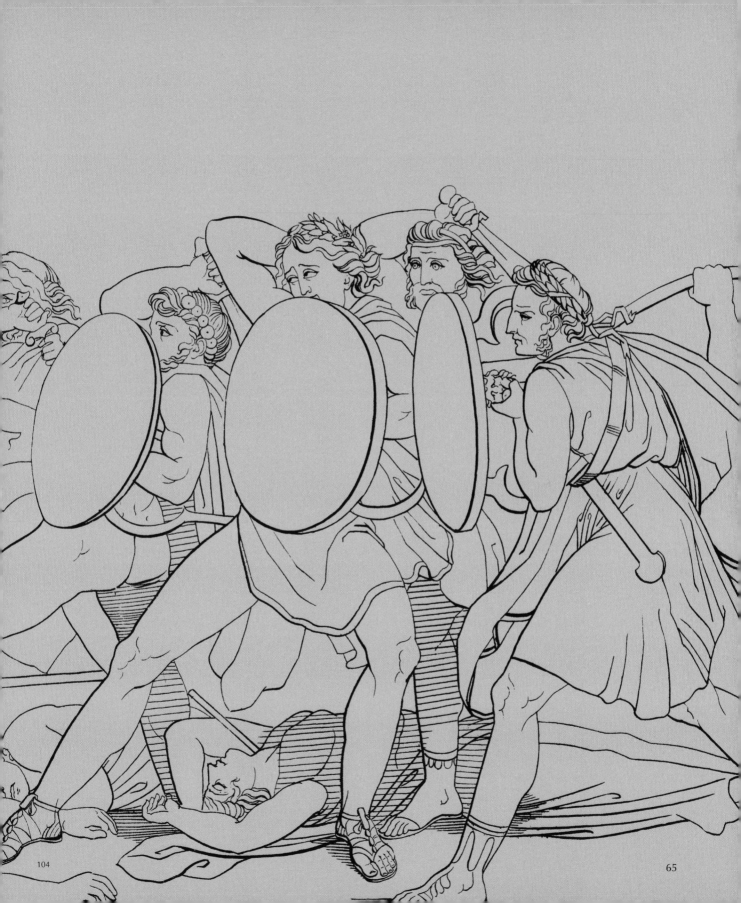

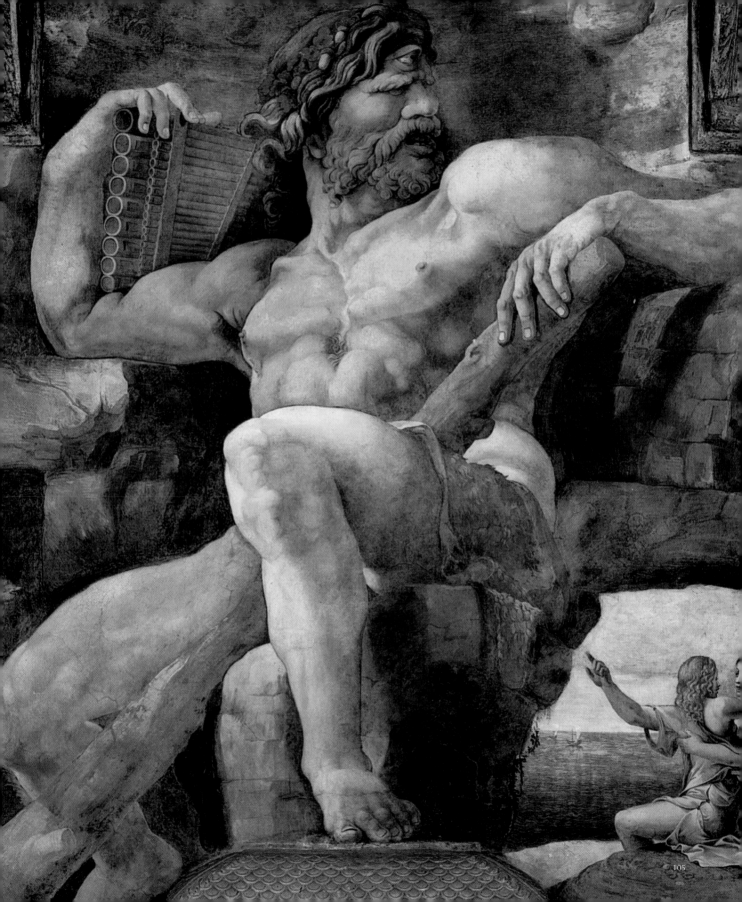

106

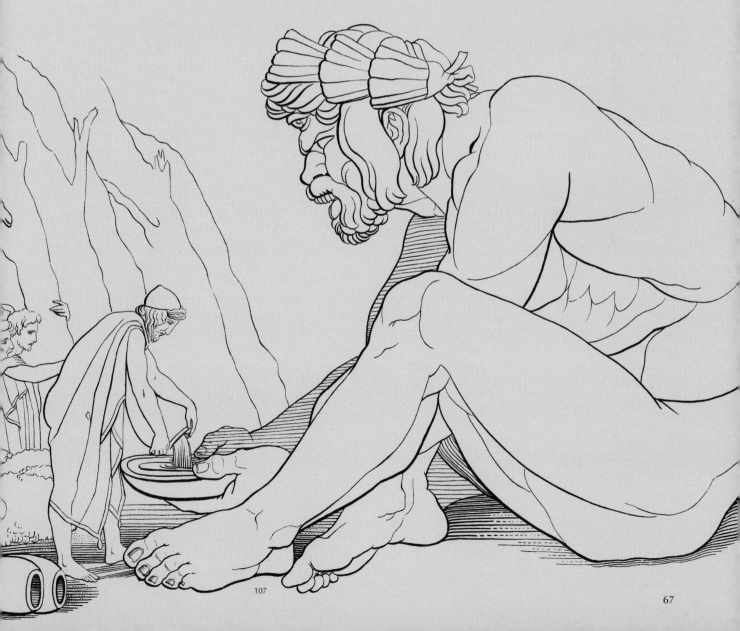

107

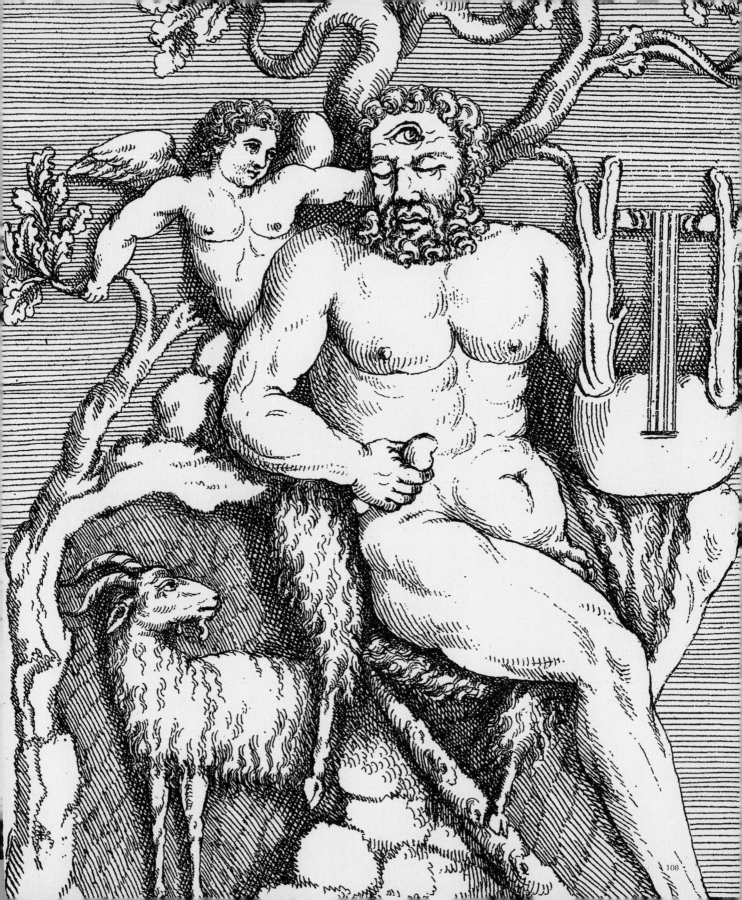

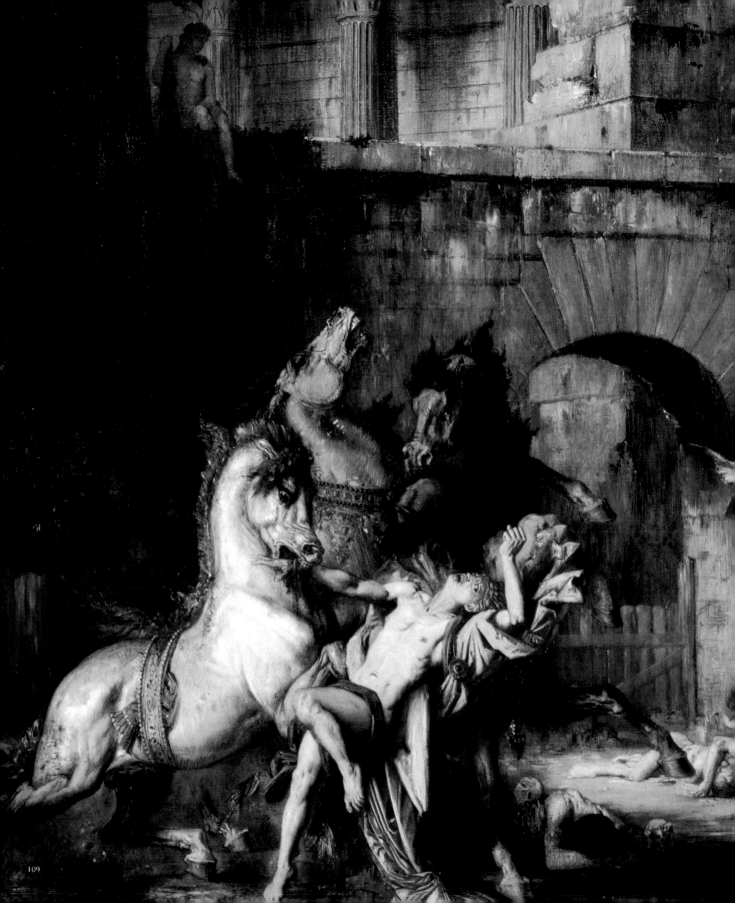

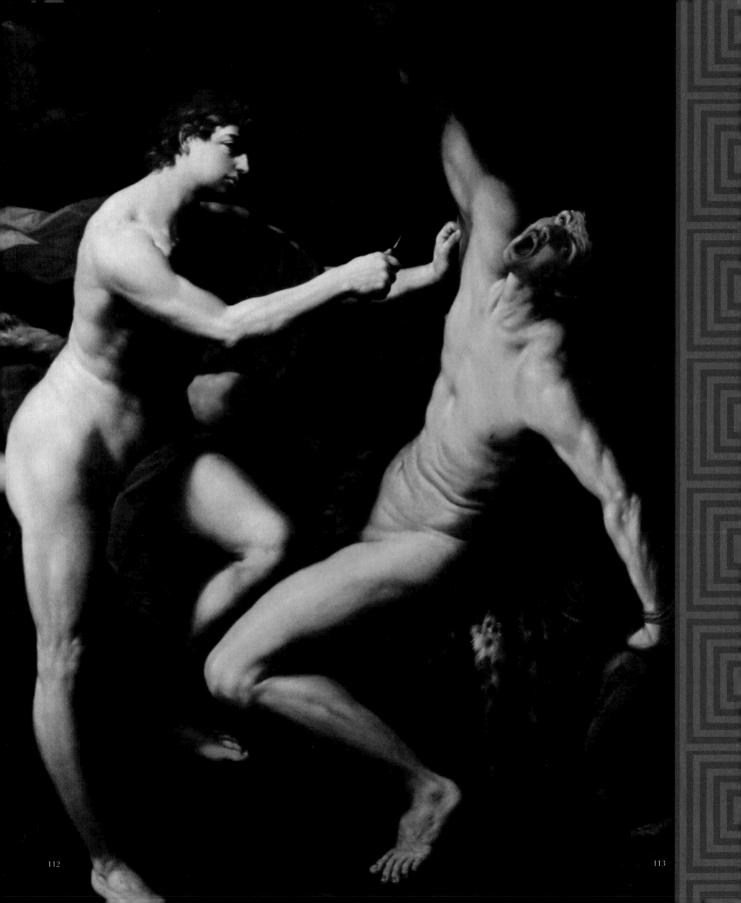

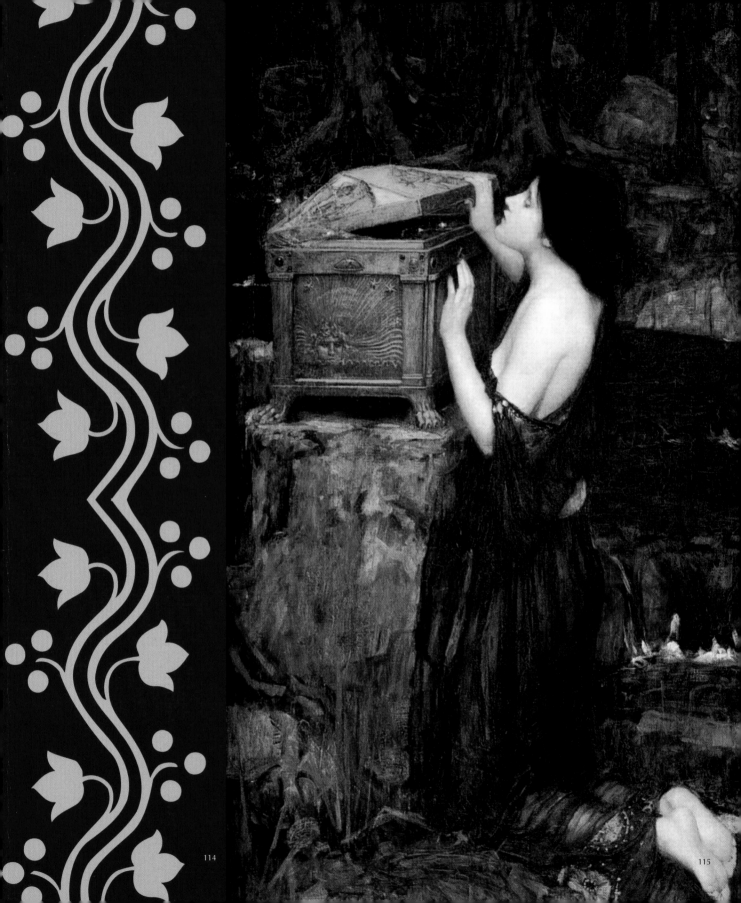

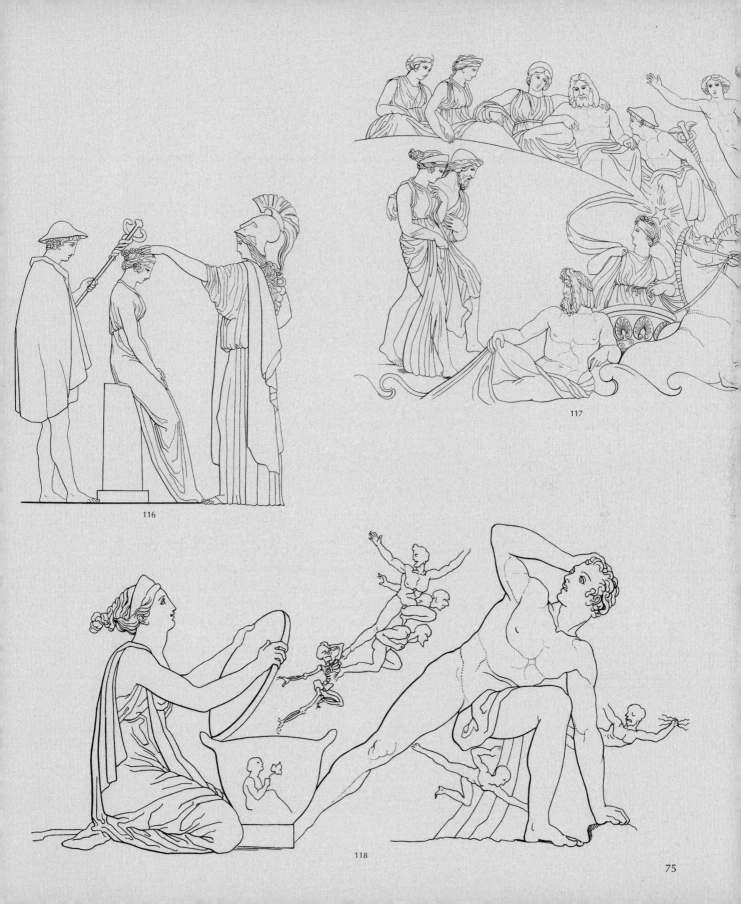

116

117

118

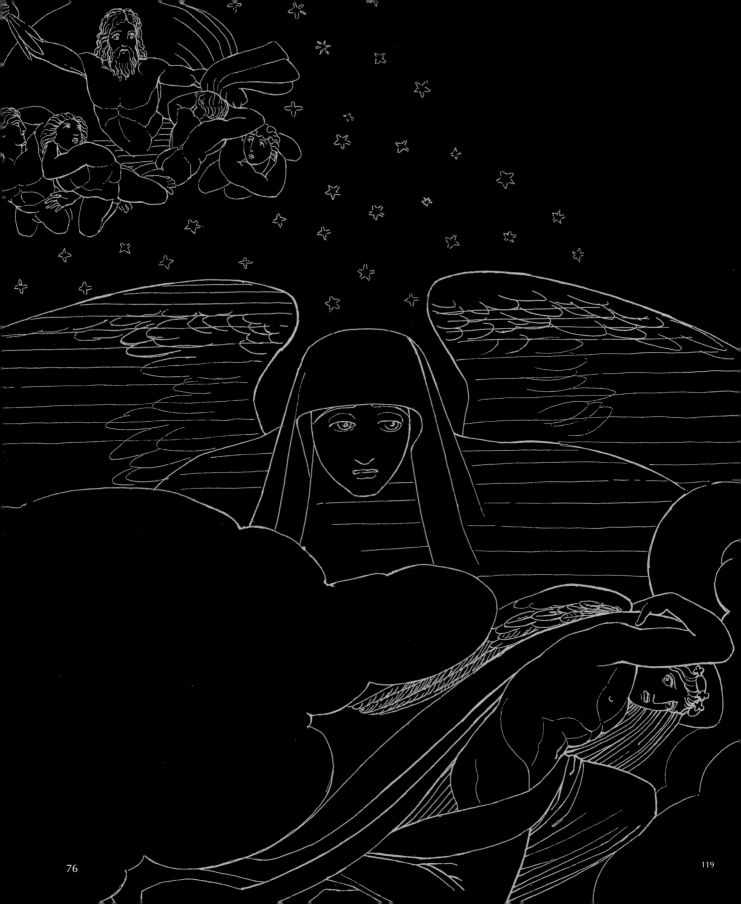

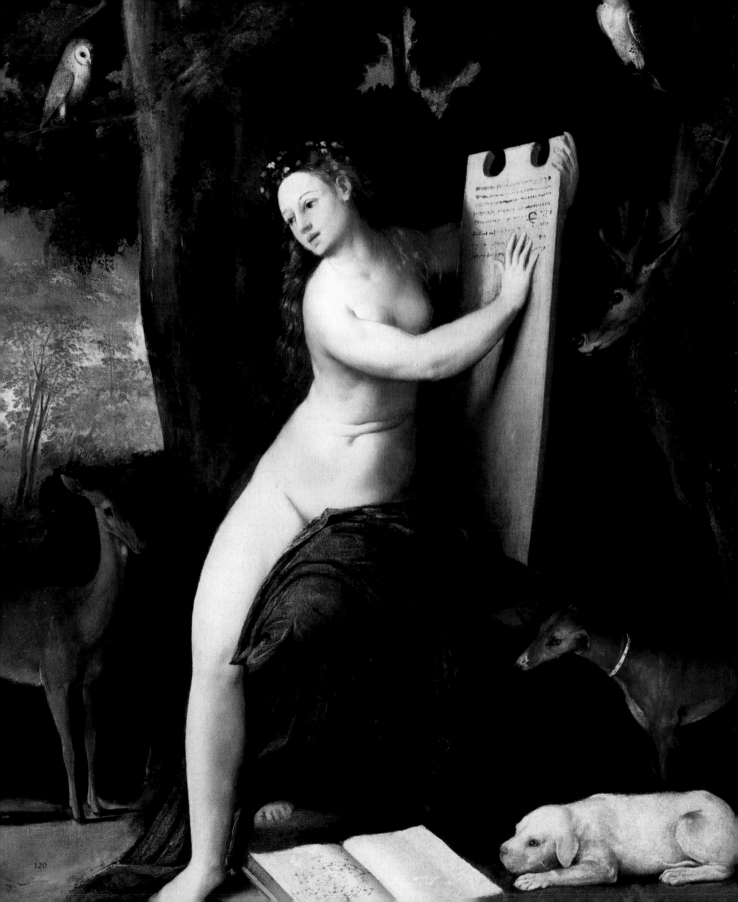

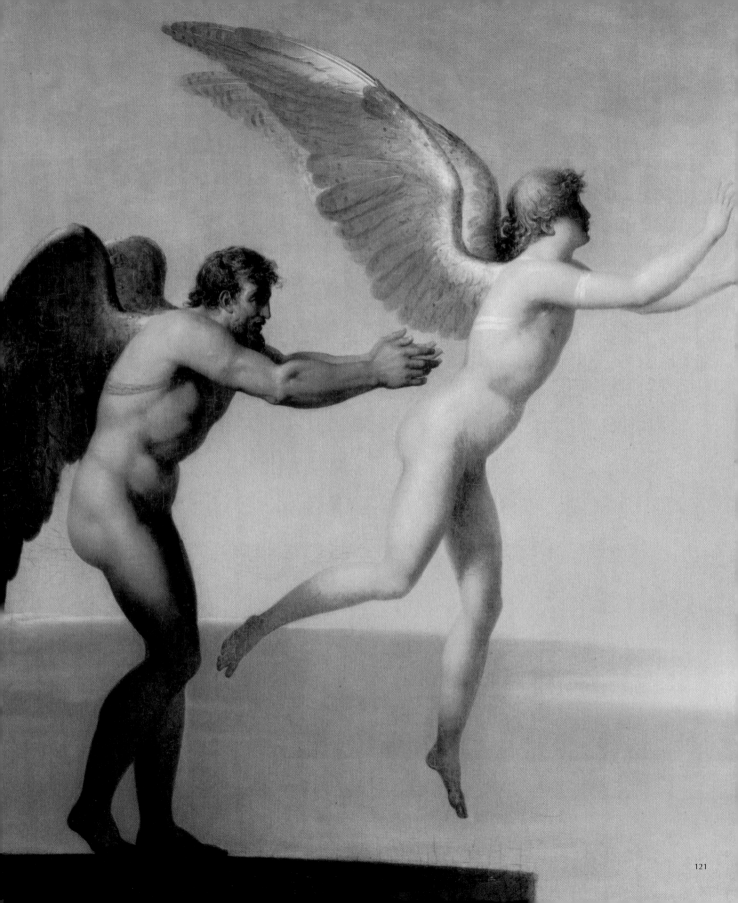

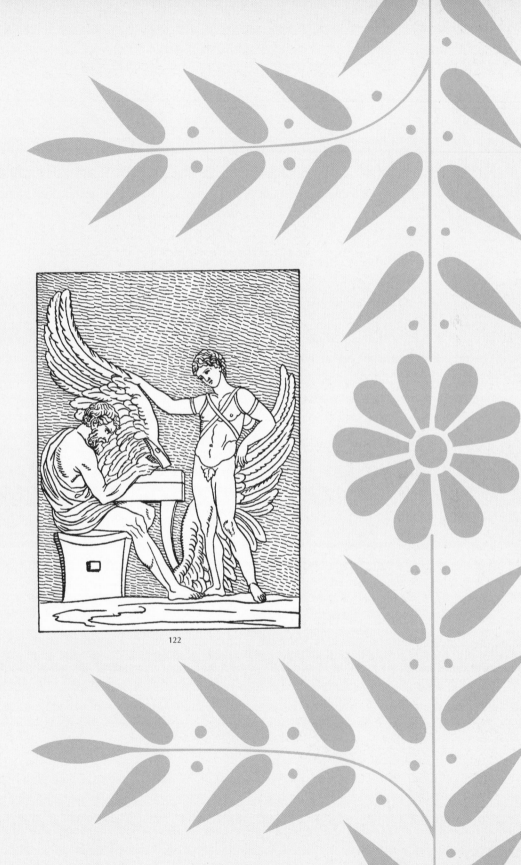

122

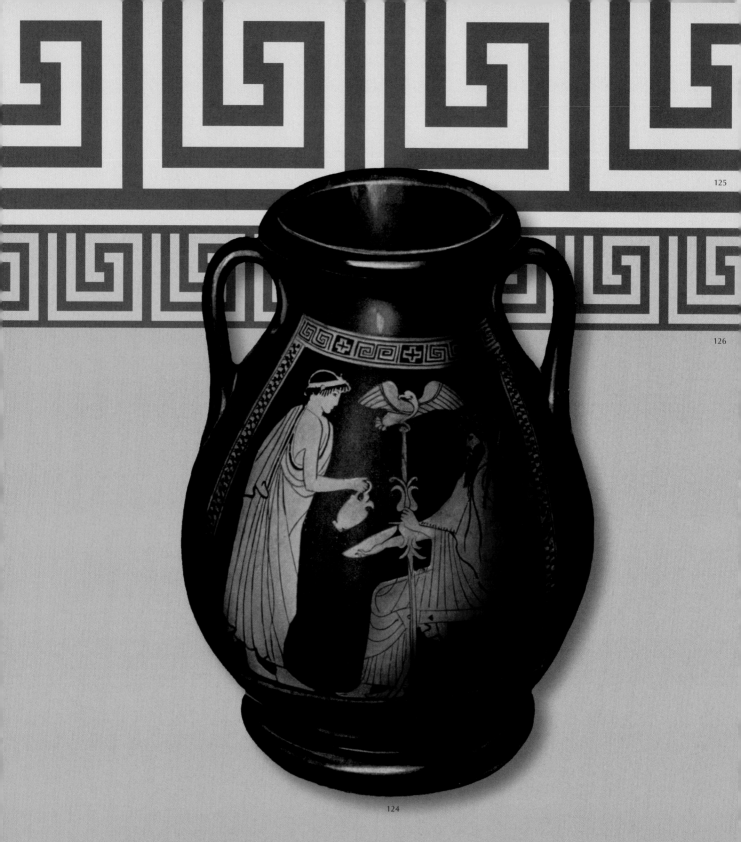

124

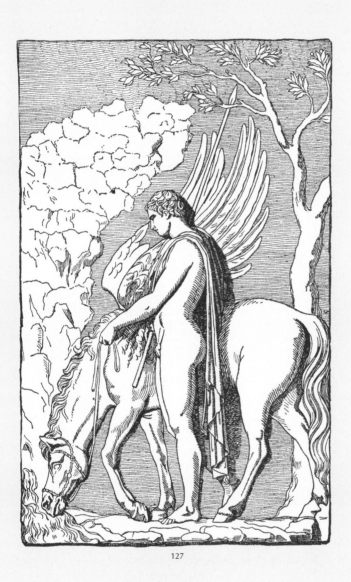

127

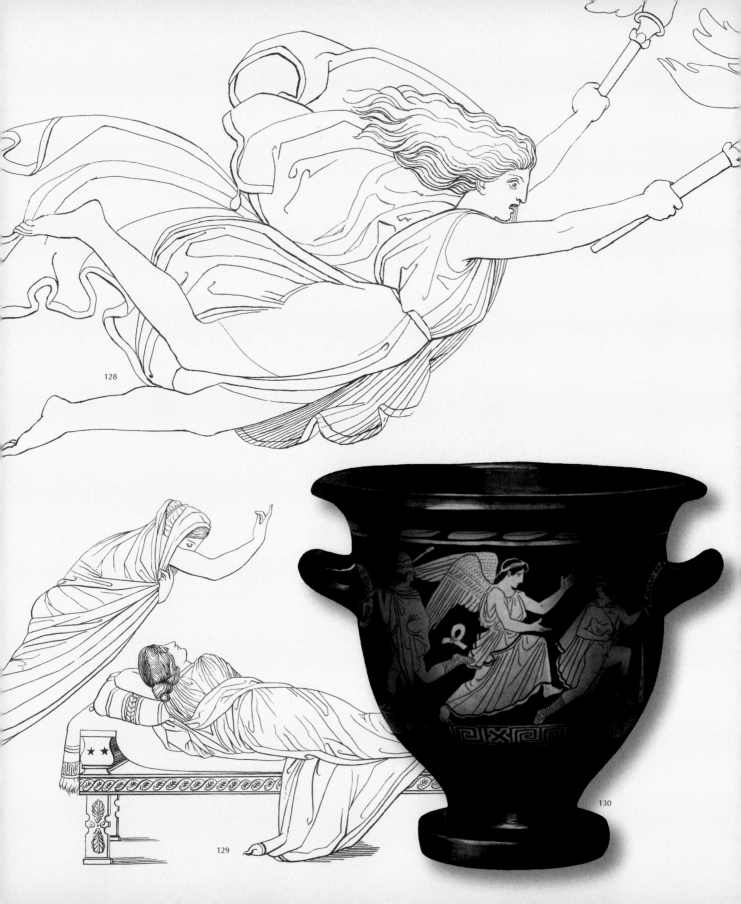

128

129

130

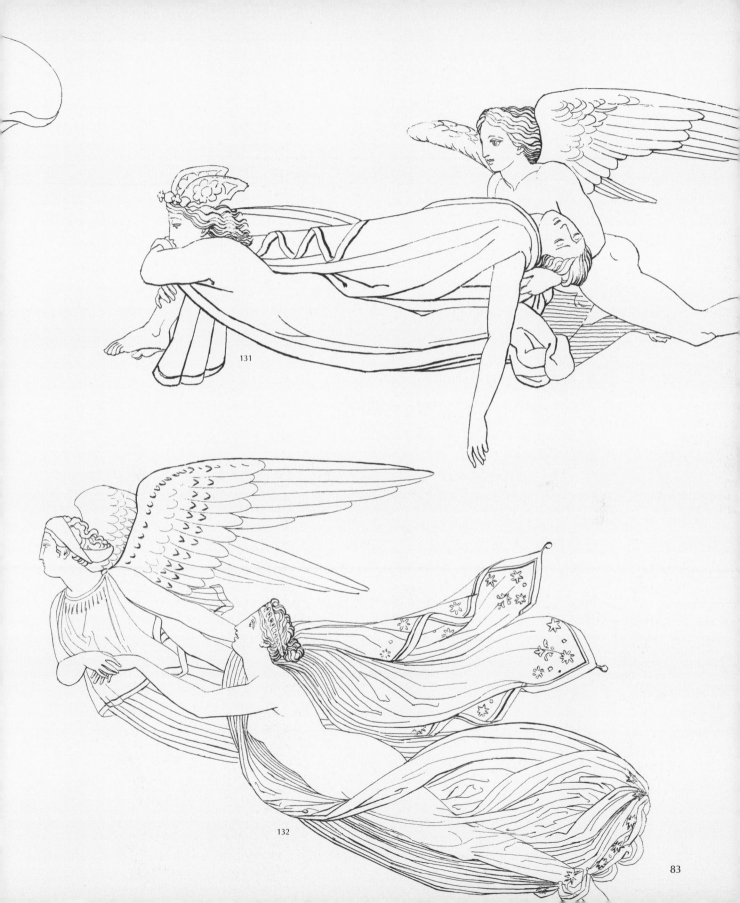

131

132

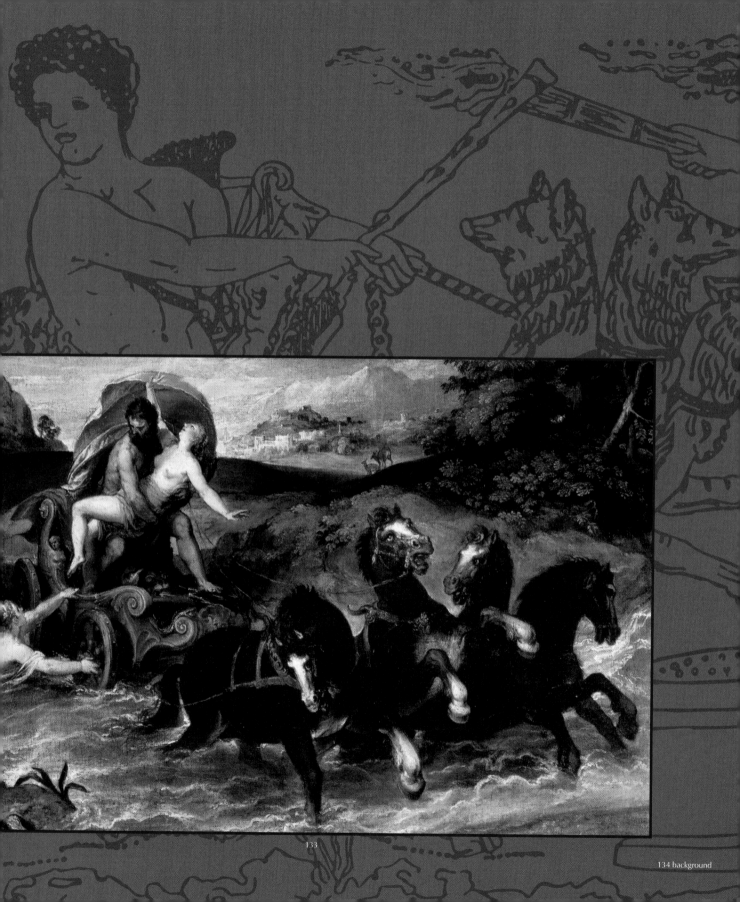

134 background

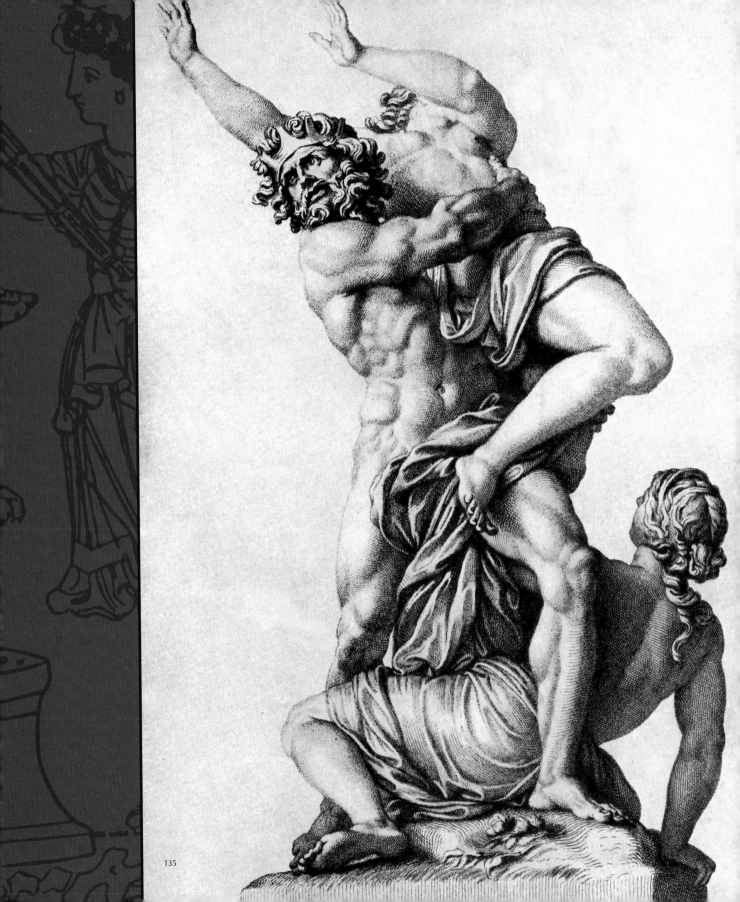

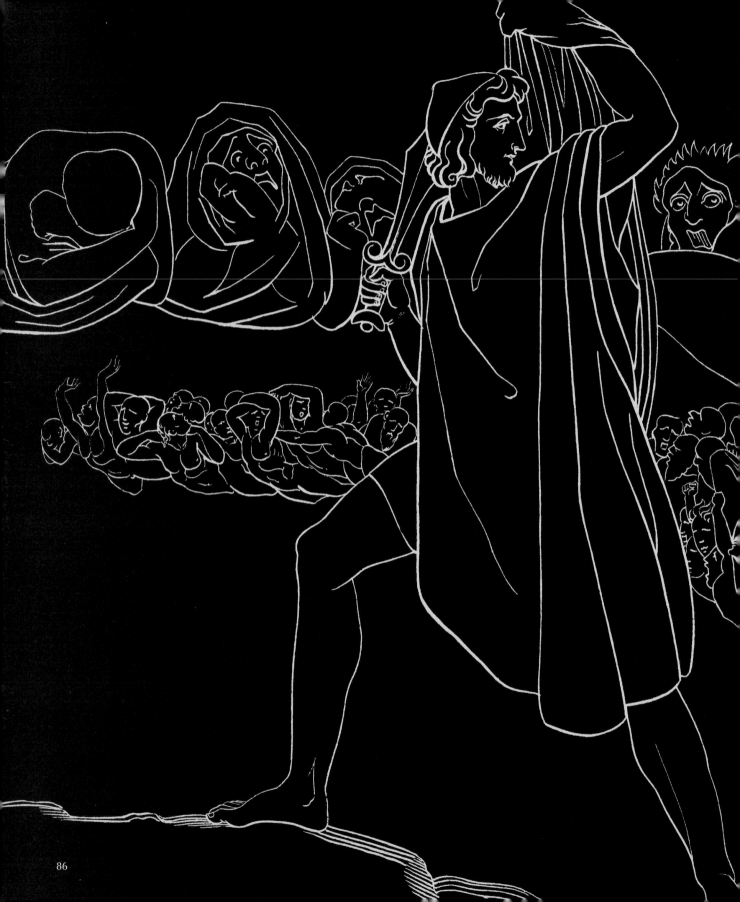

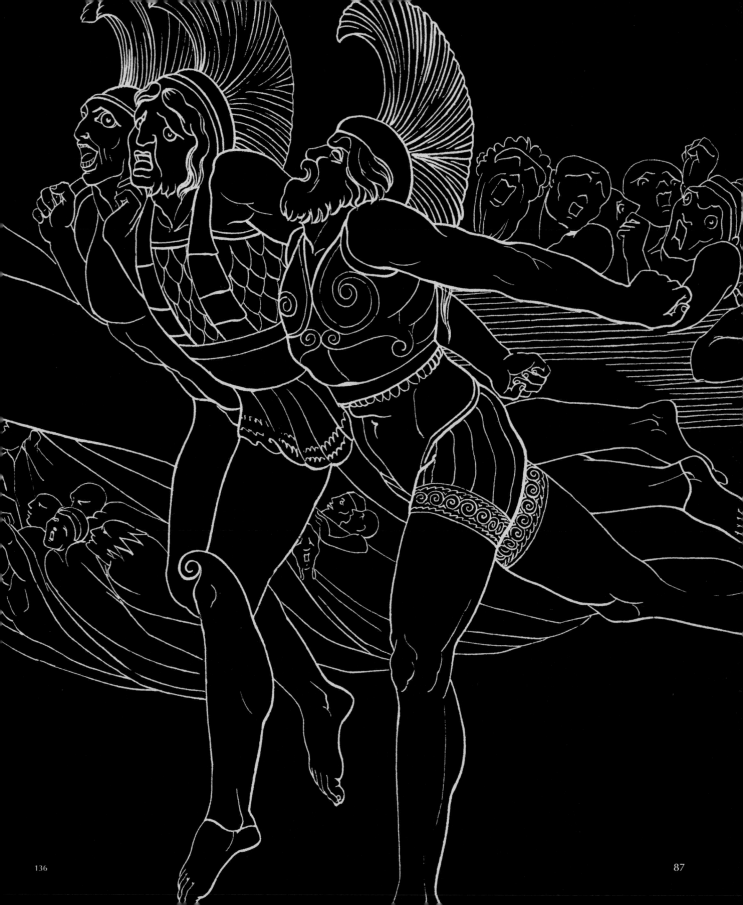

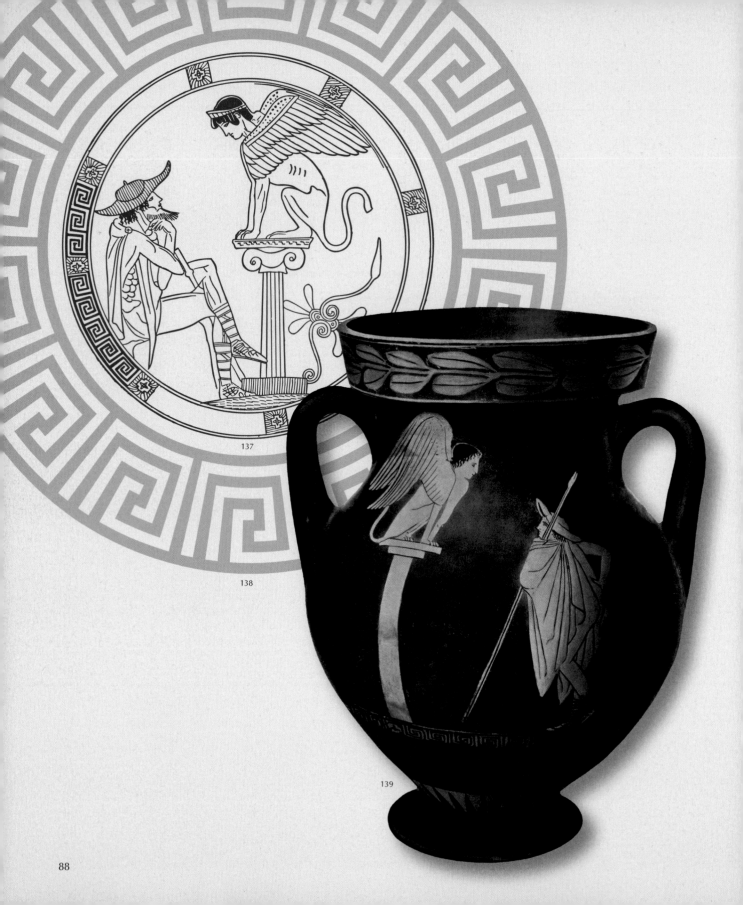

137

138

139

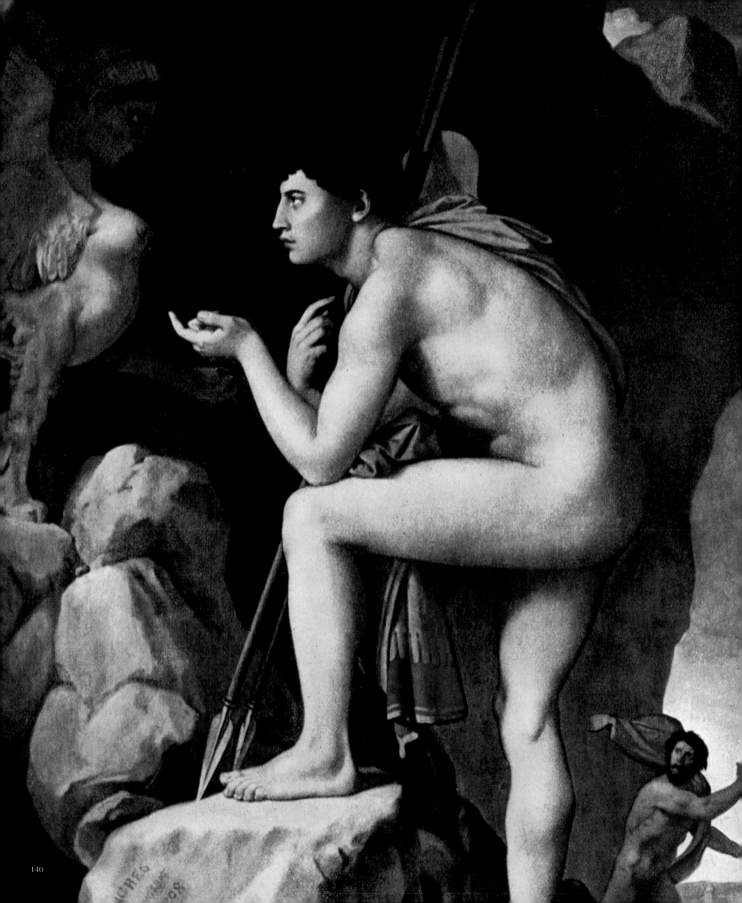

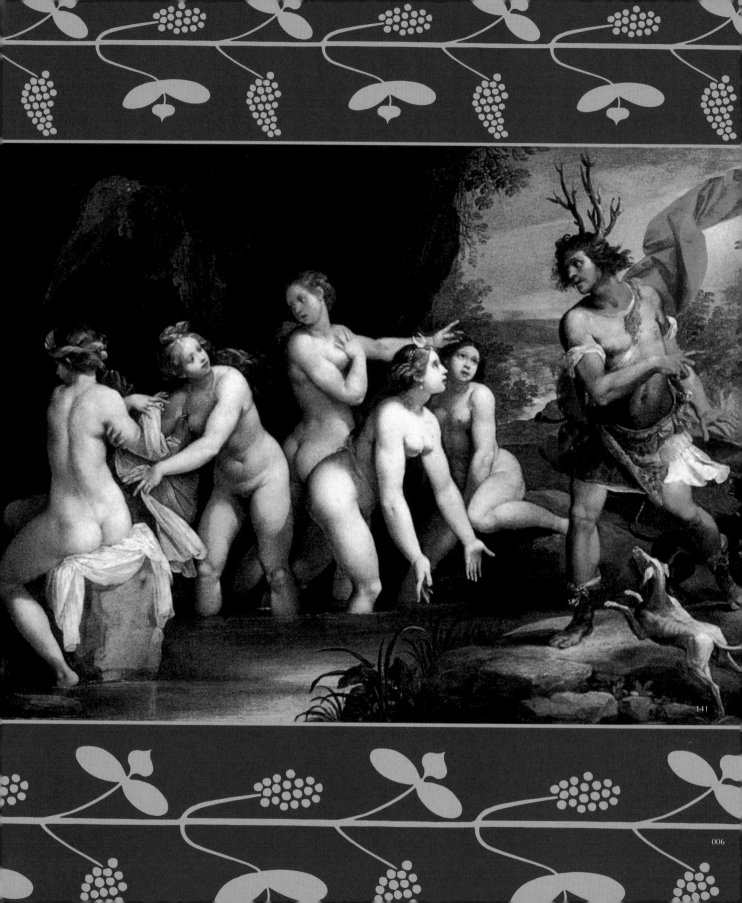

141

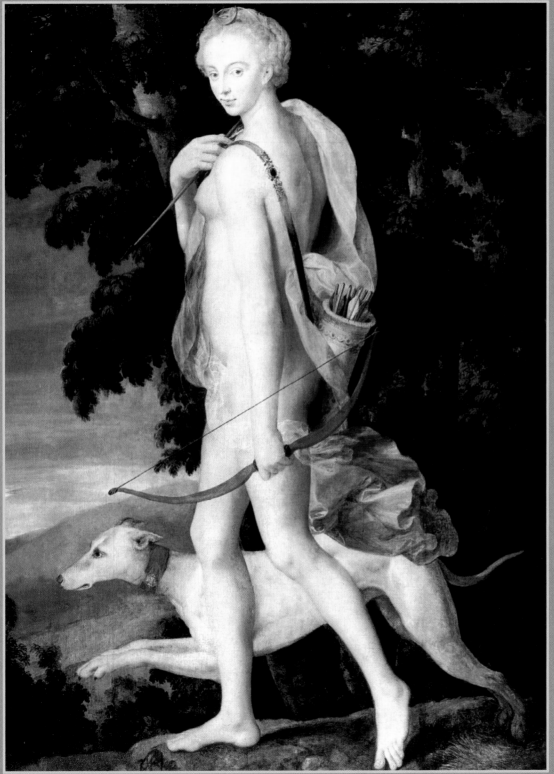

142

143

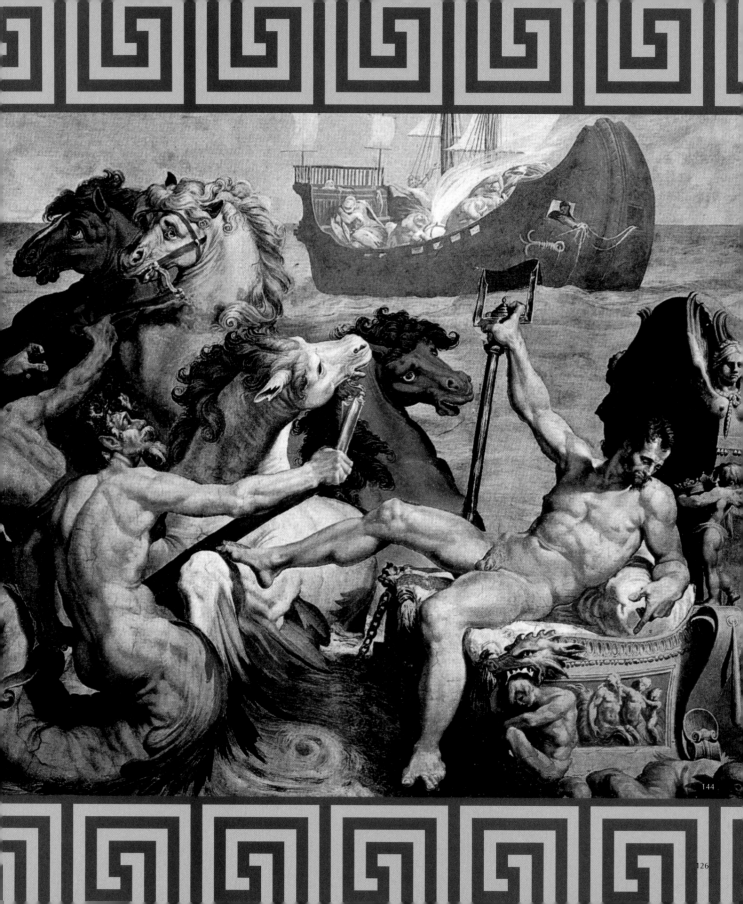

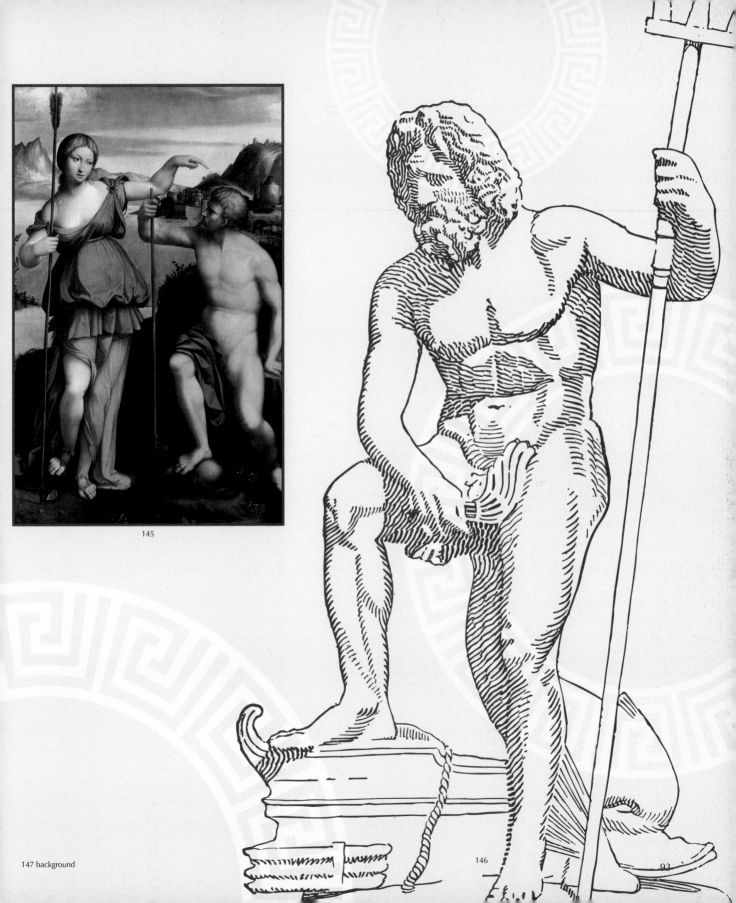

145

147 background

146

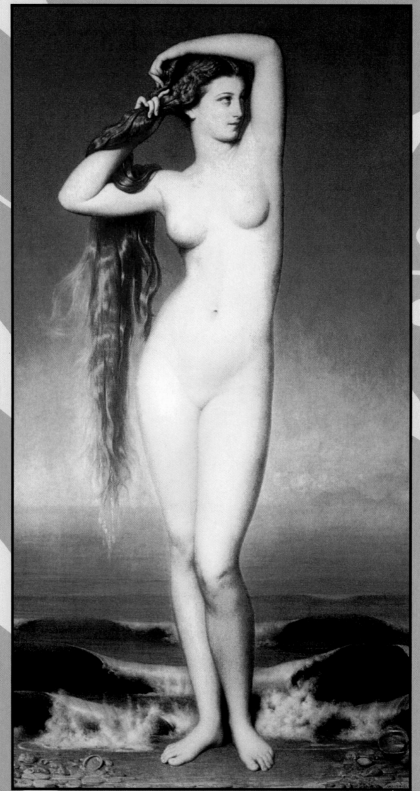

148

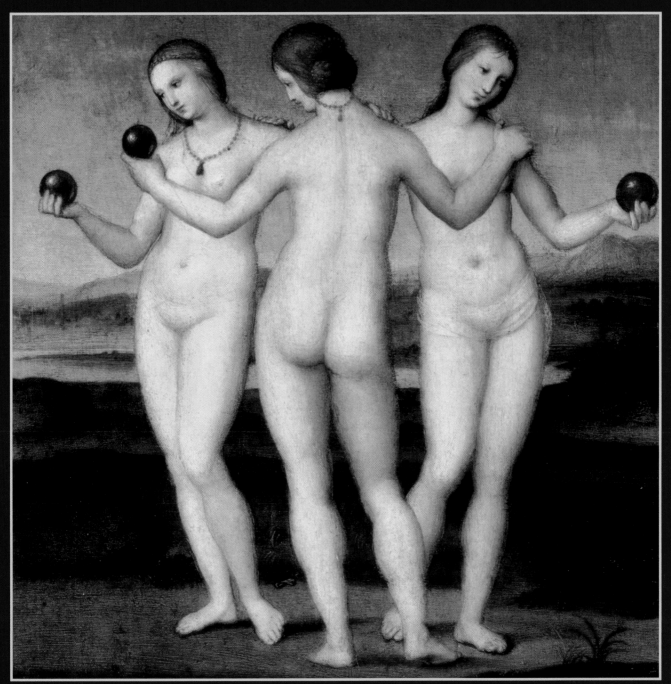

150

151

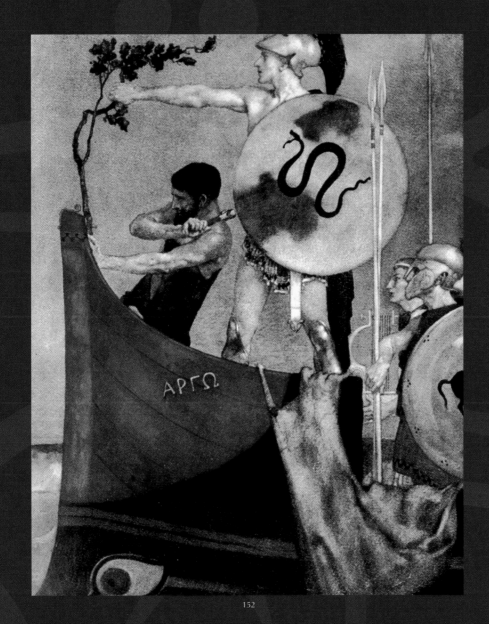

152

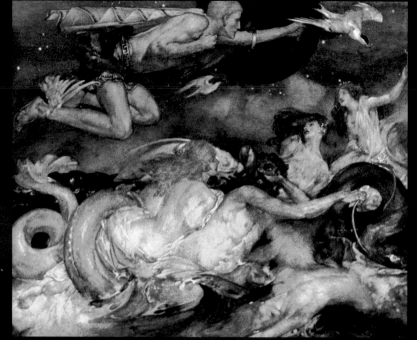

154

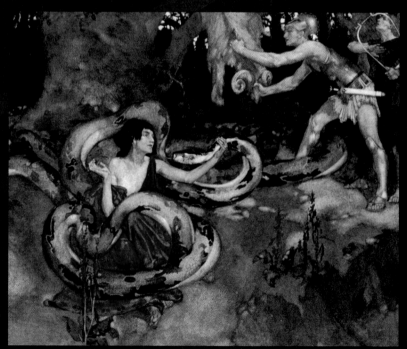

155

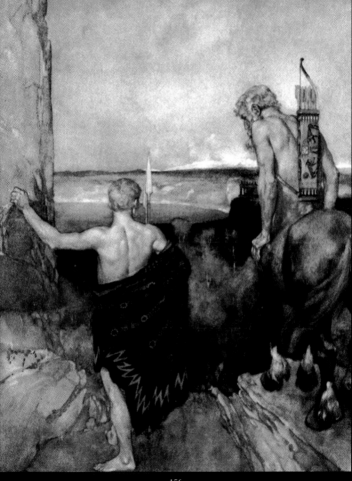

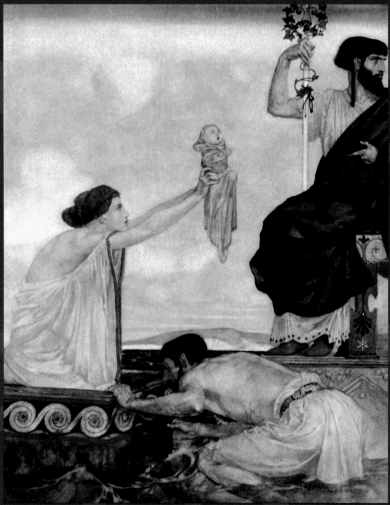

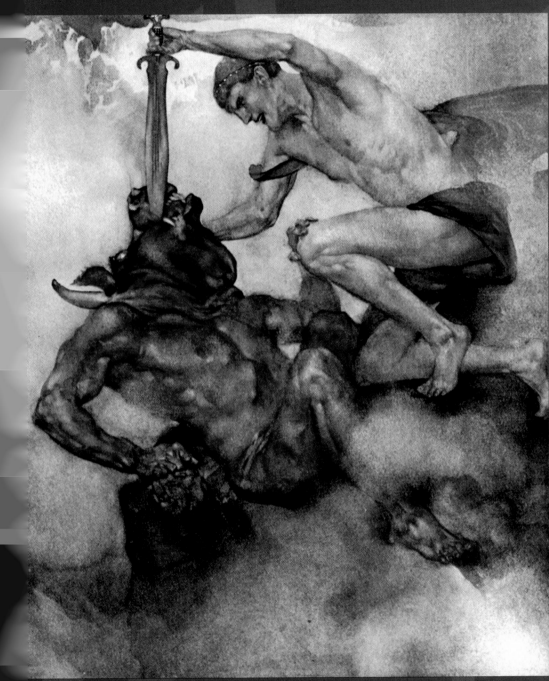

159

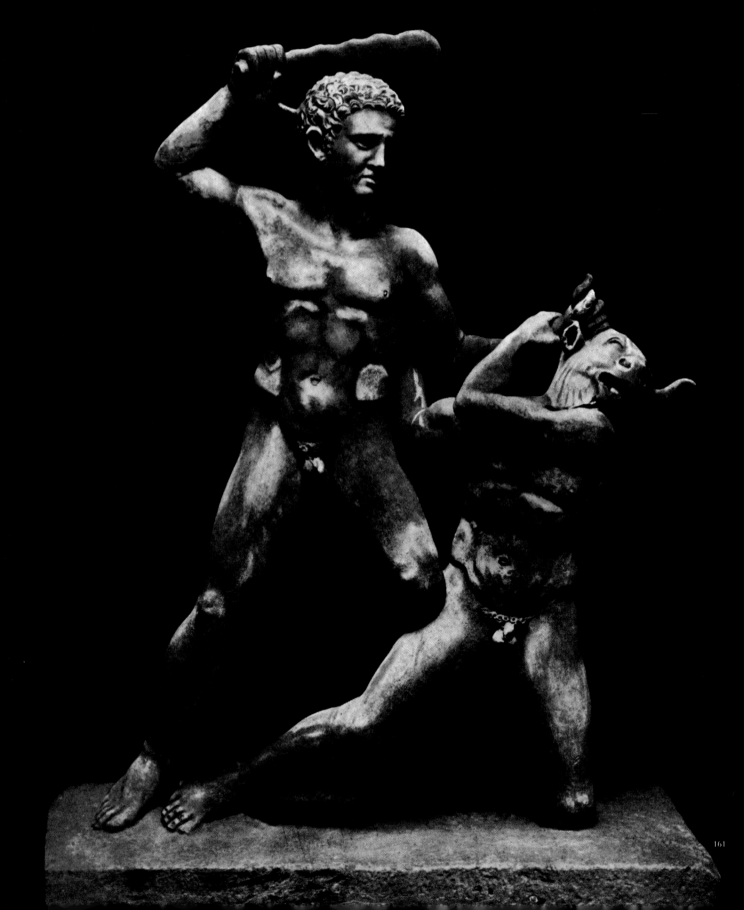

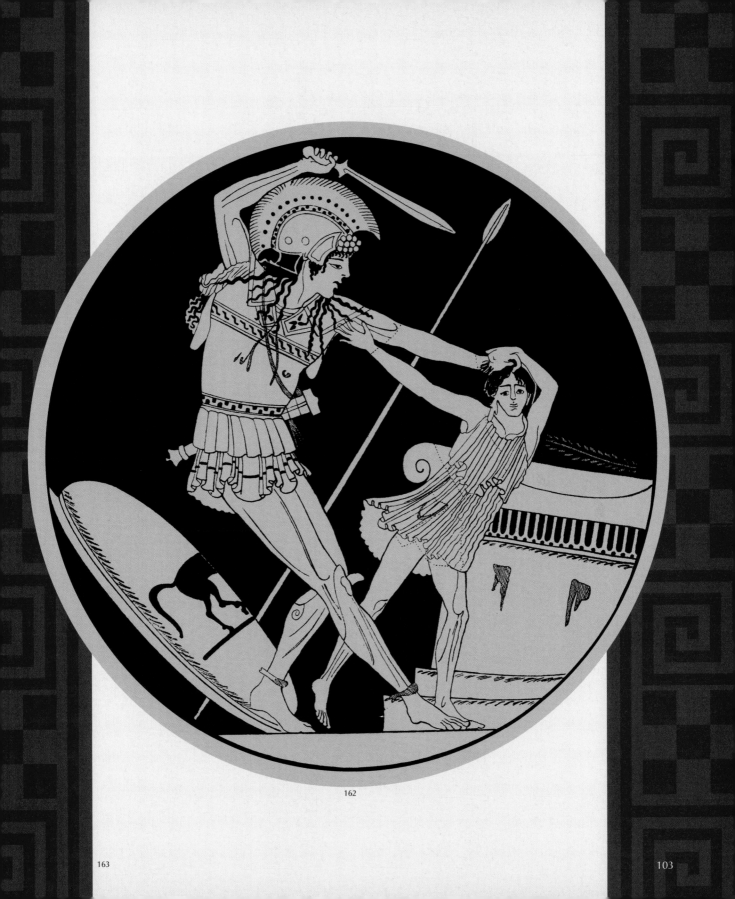

162

163

165

166

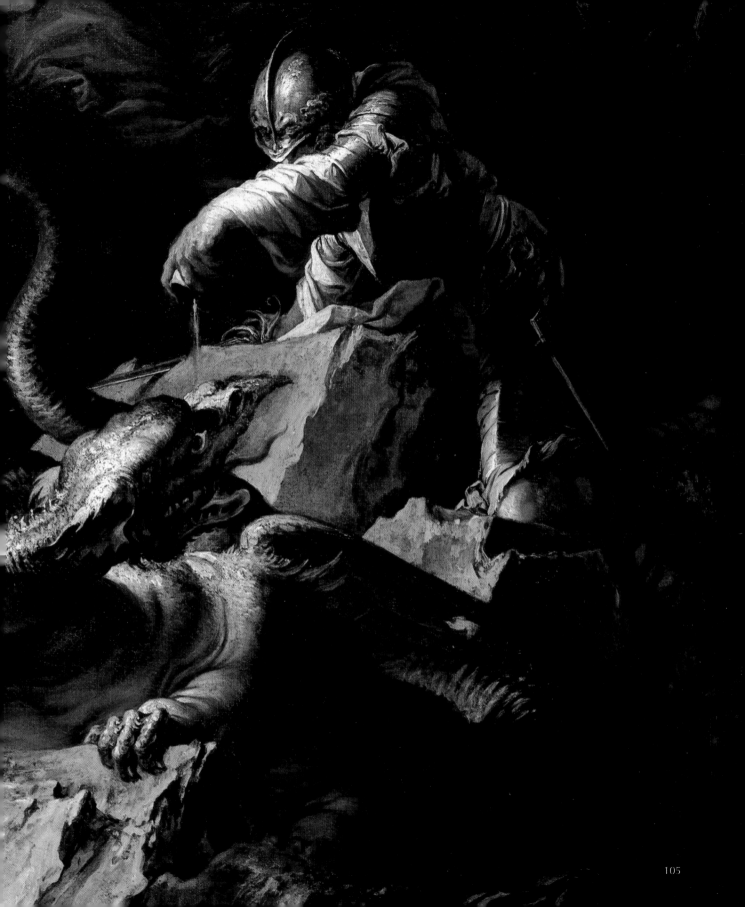

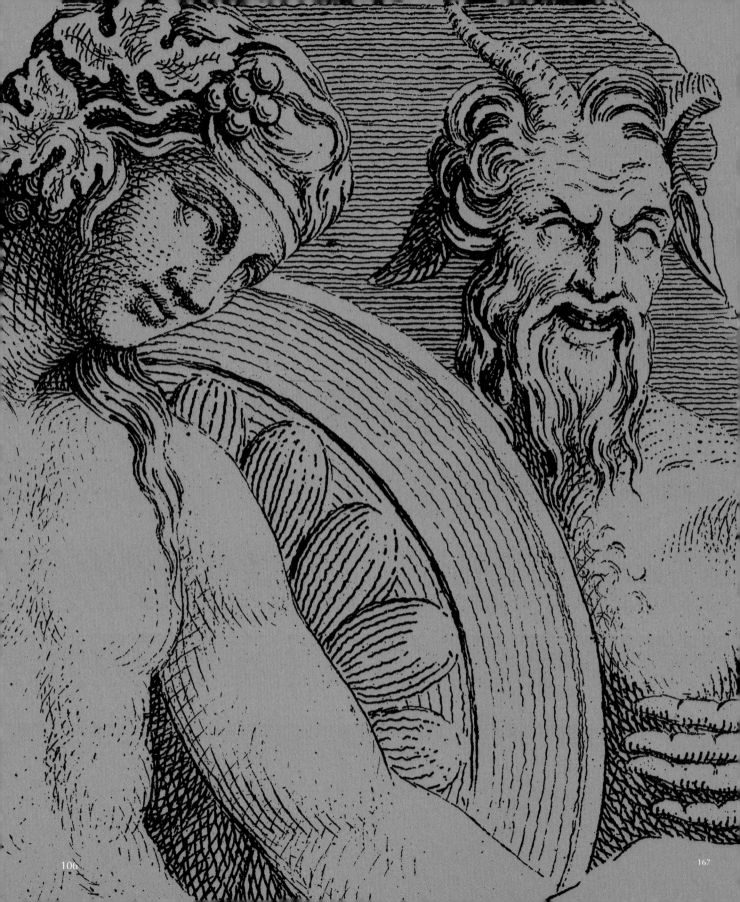

168

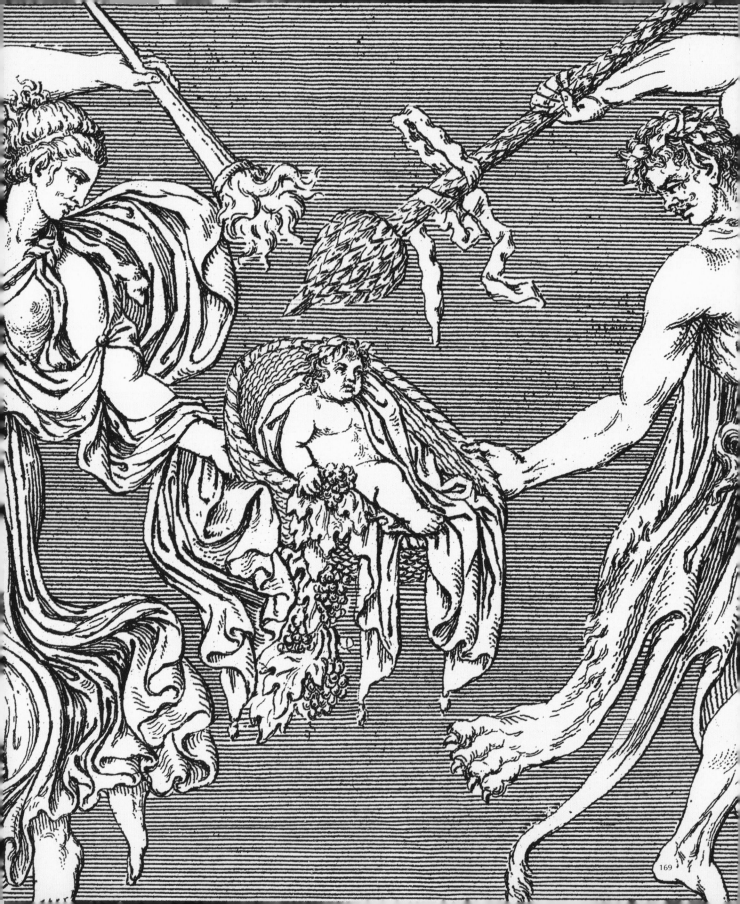

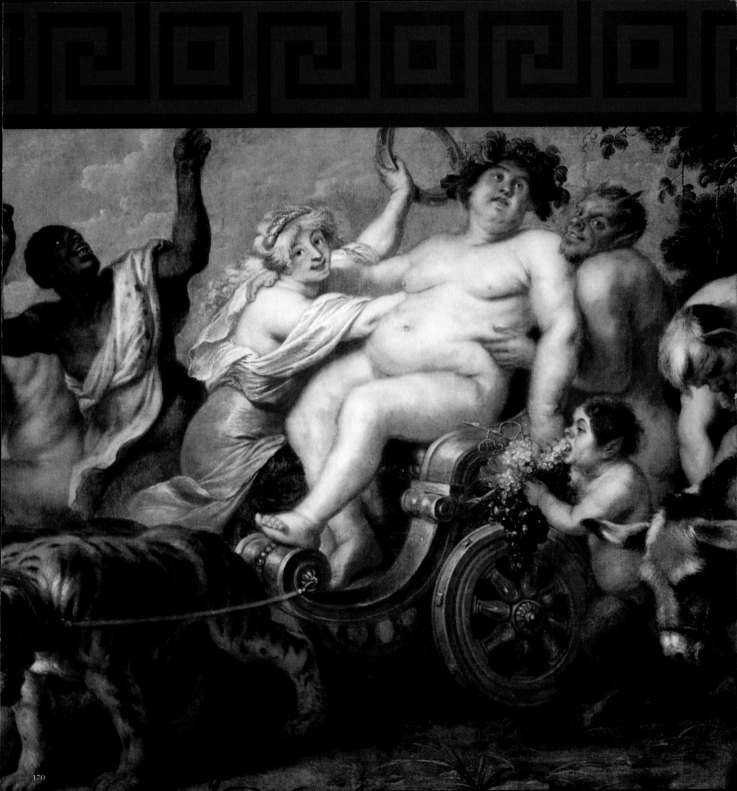

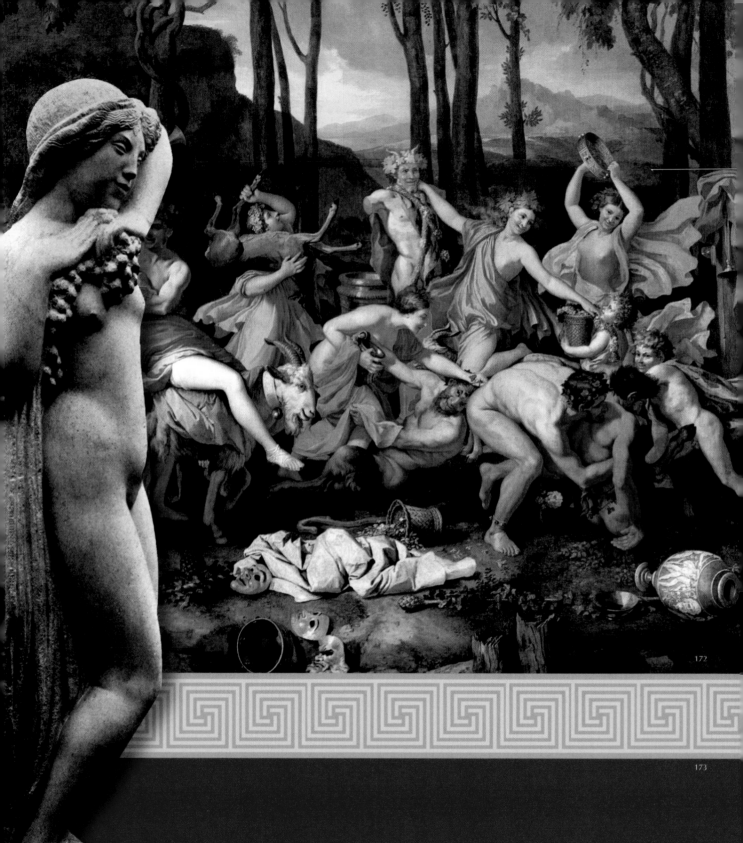

172

173

174

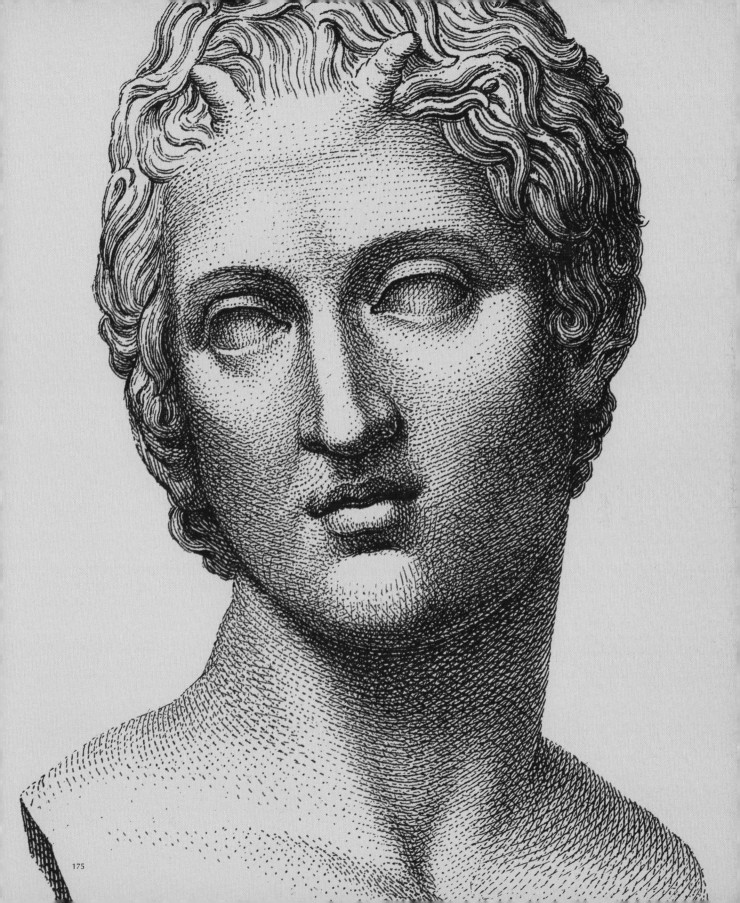

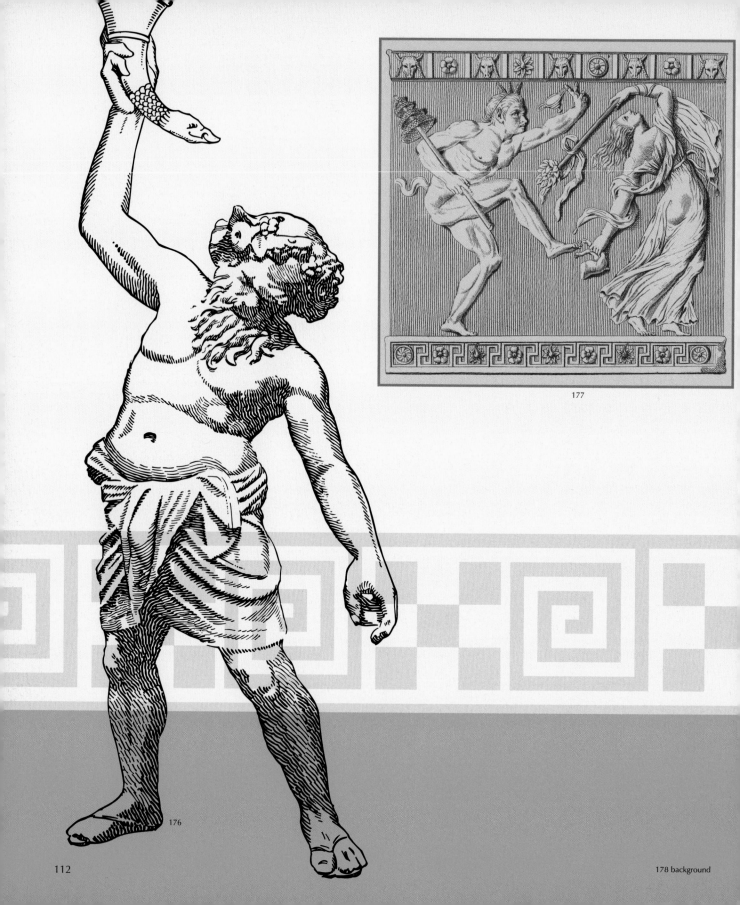

177

178 background

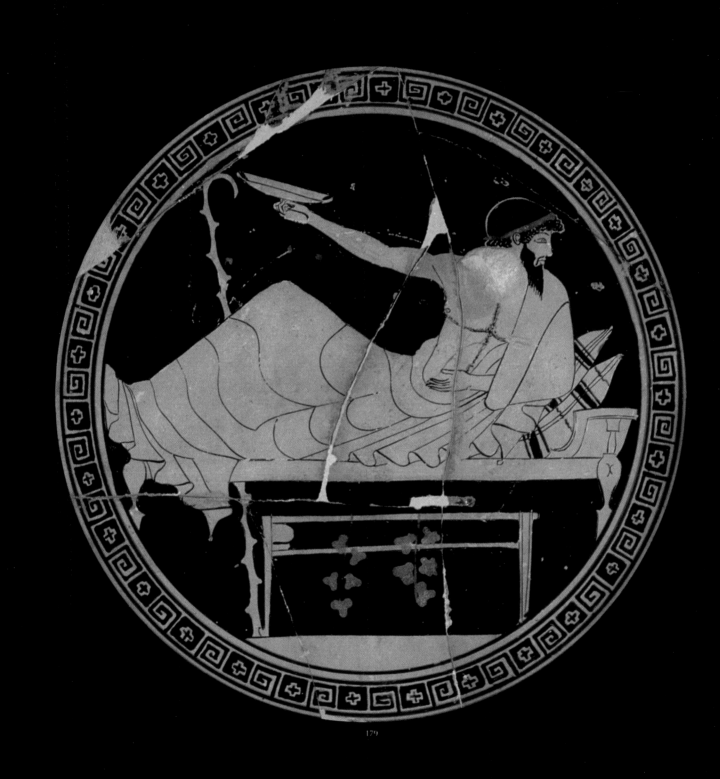

179

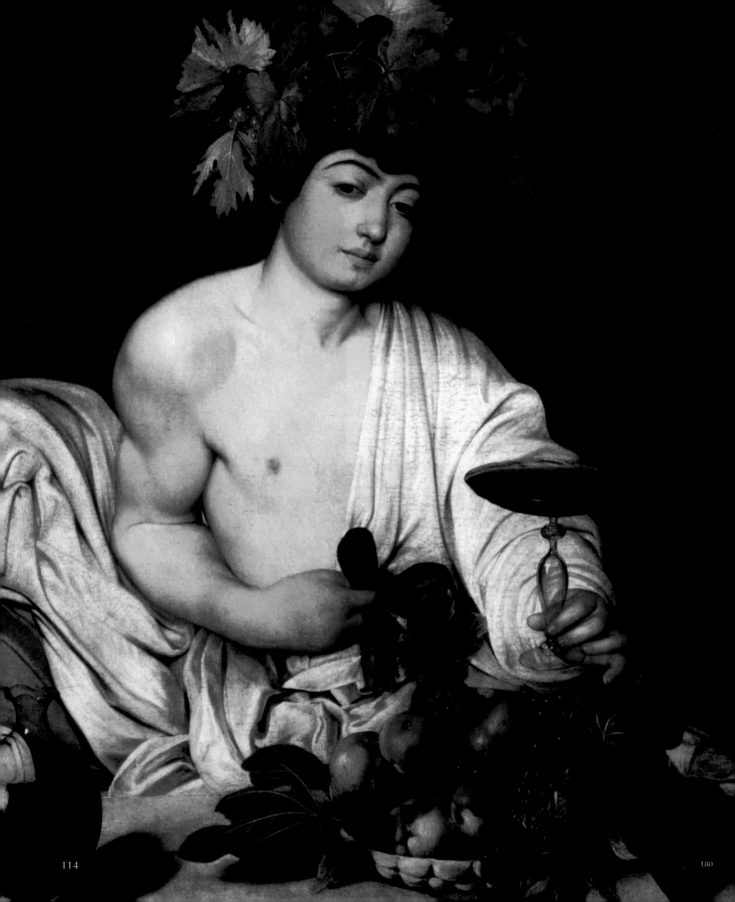

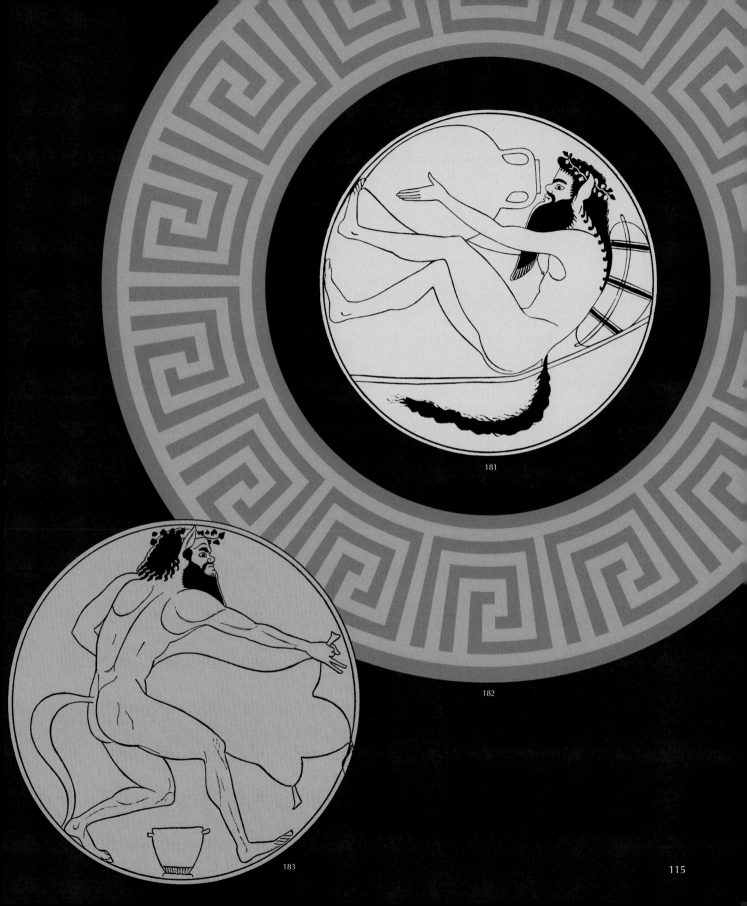

181

182

183

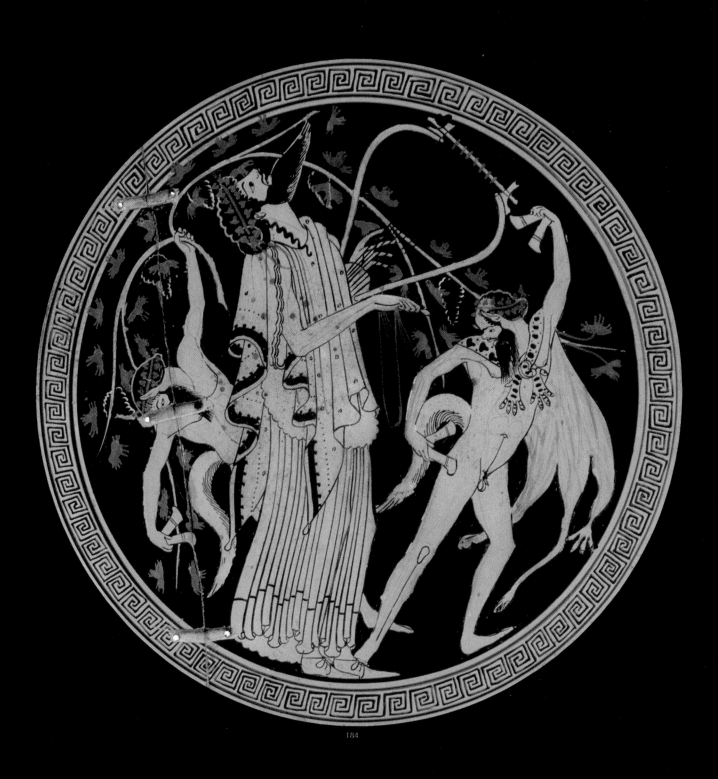

184

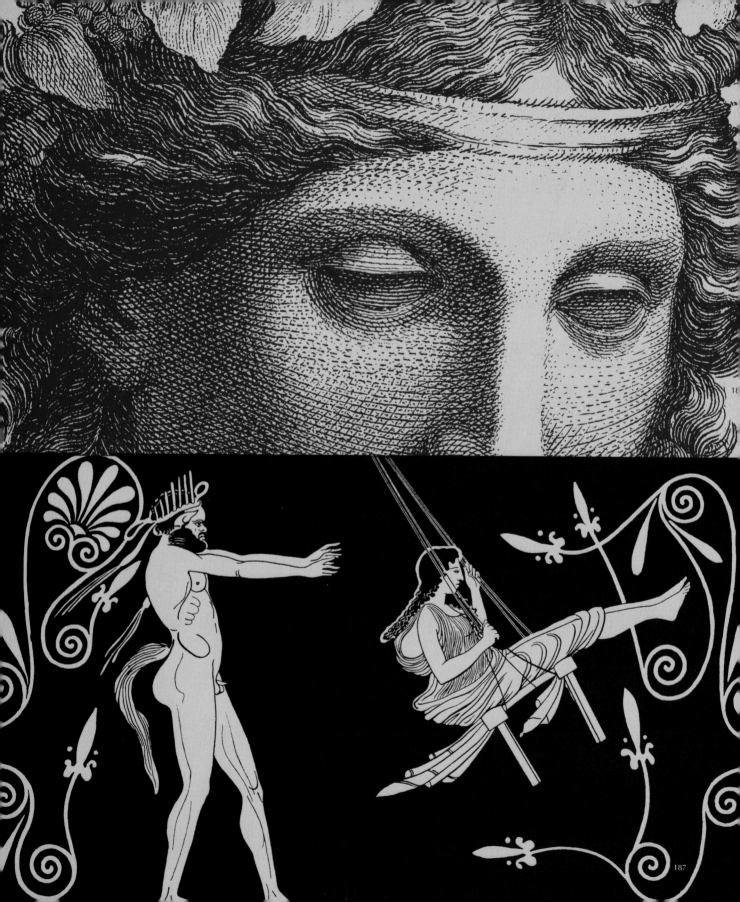

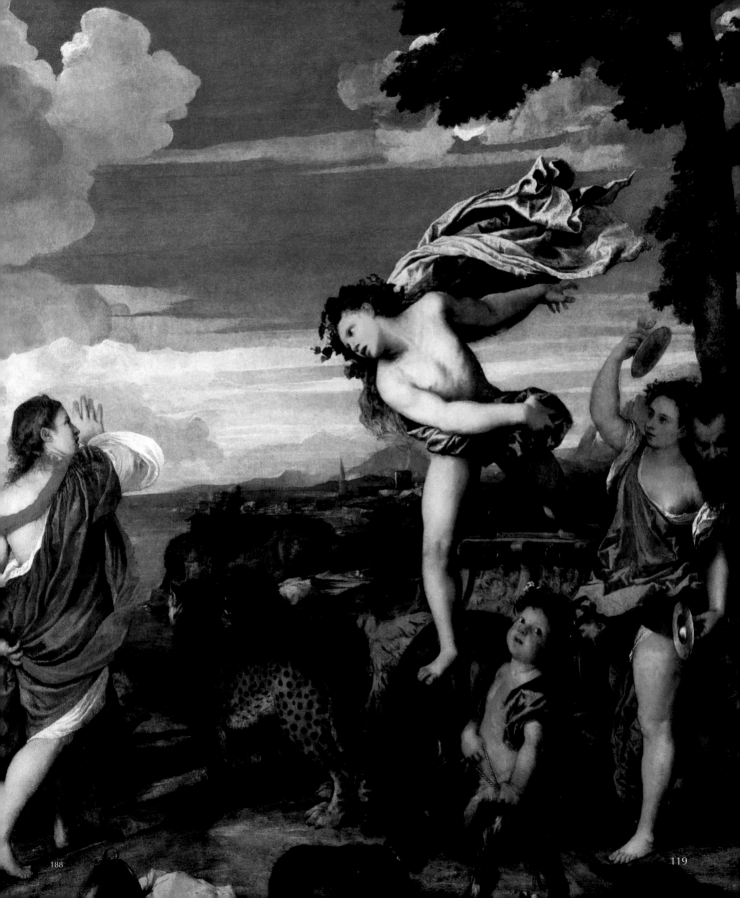

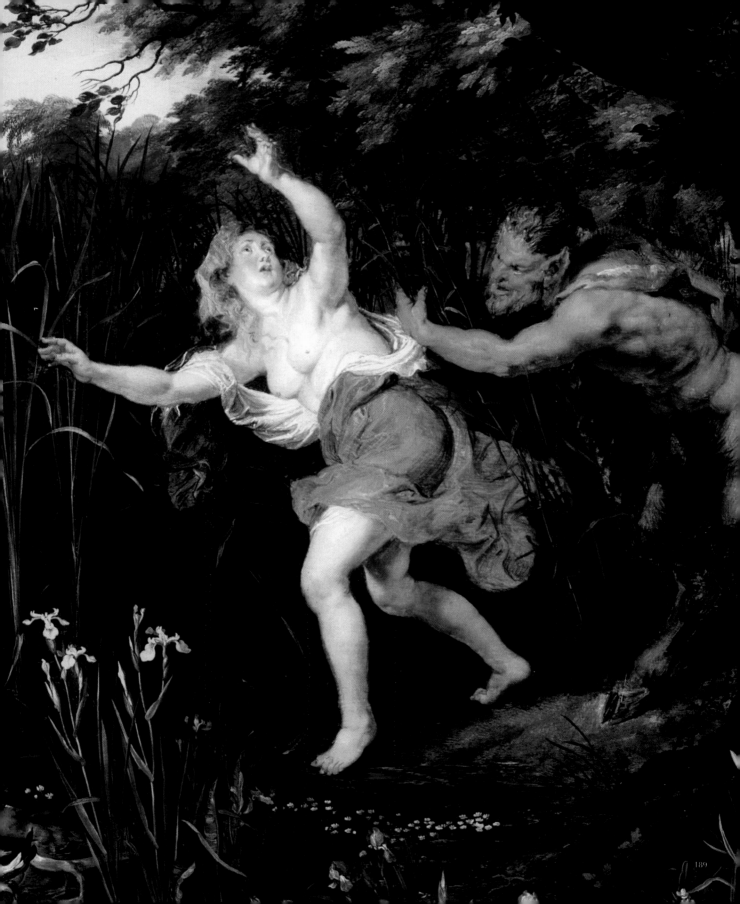

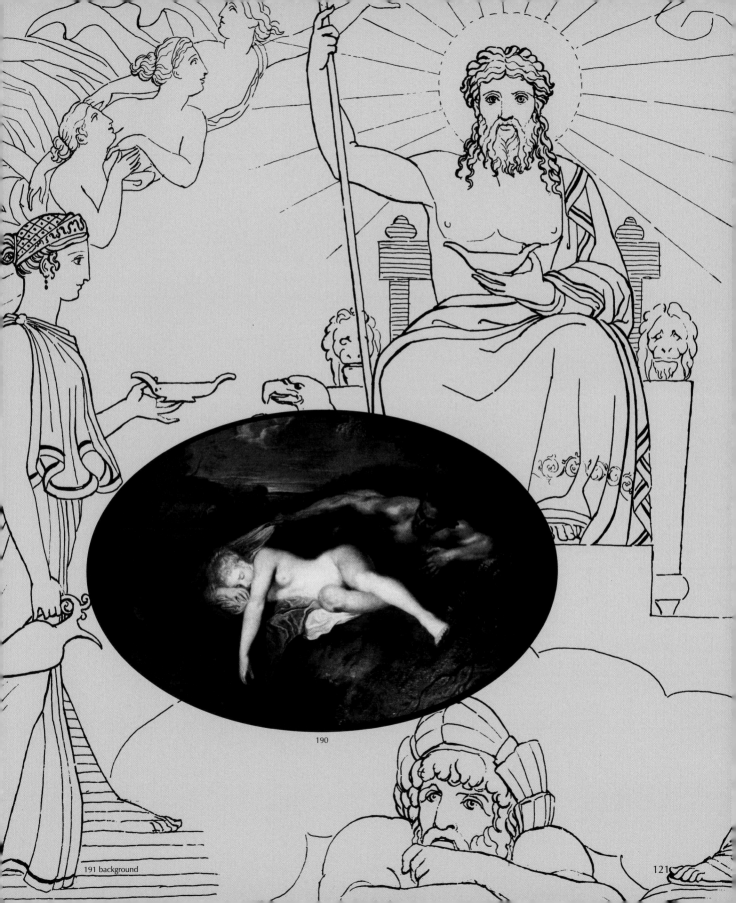

190

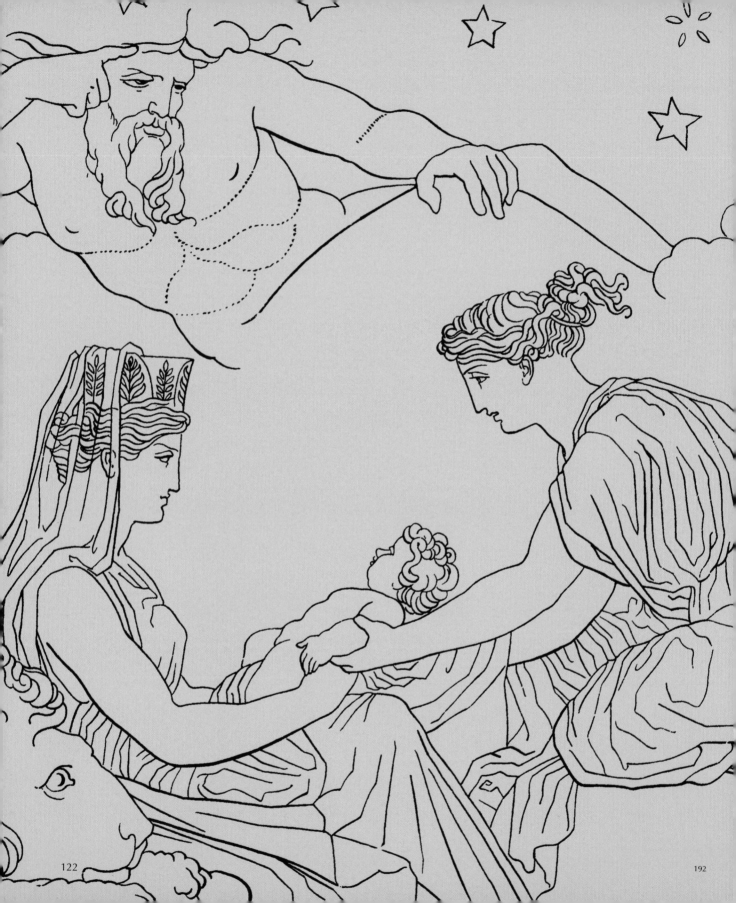

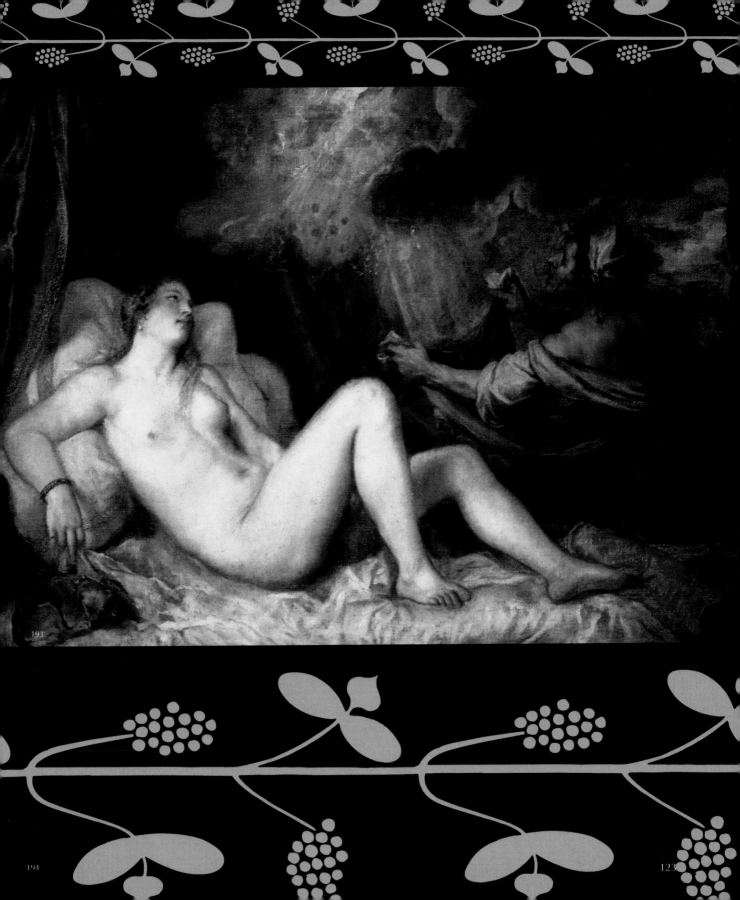

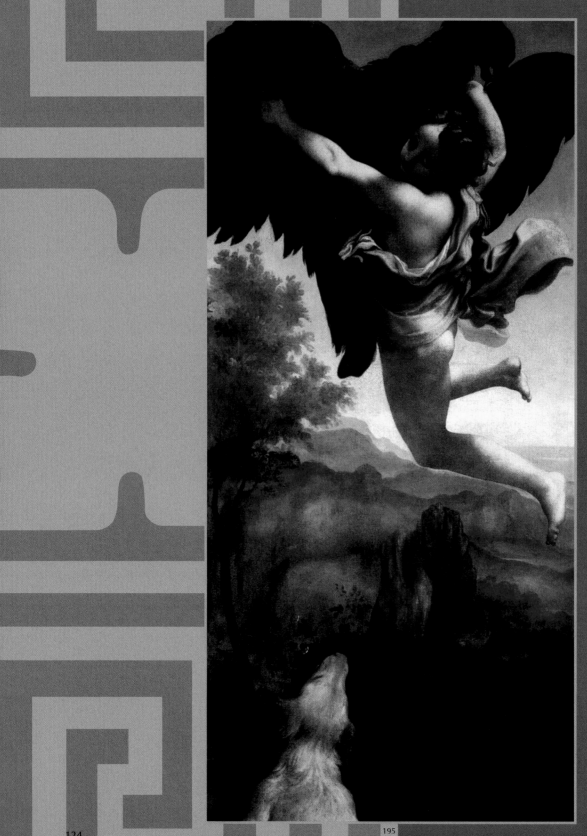

195

196 background

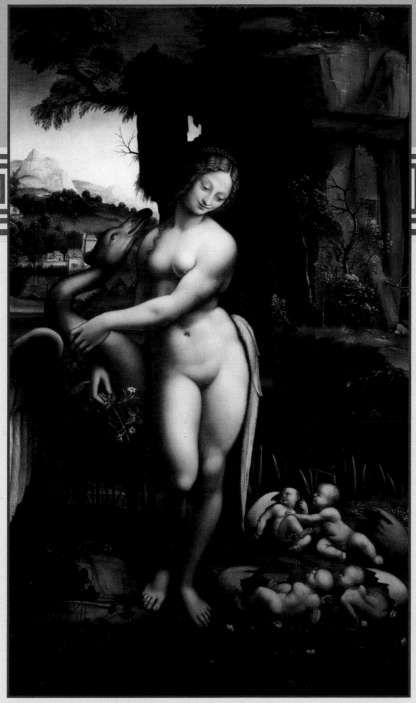

197

199

200 background

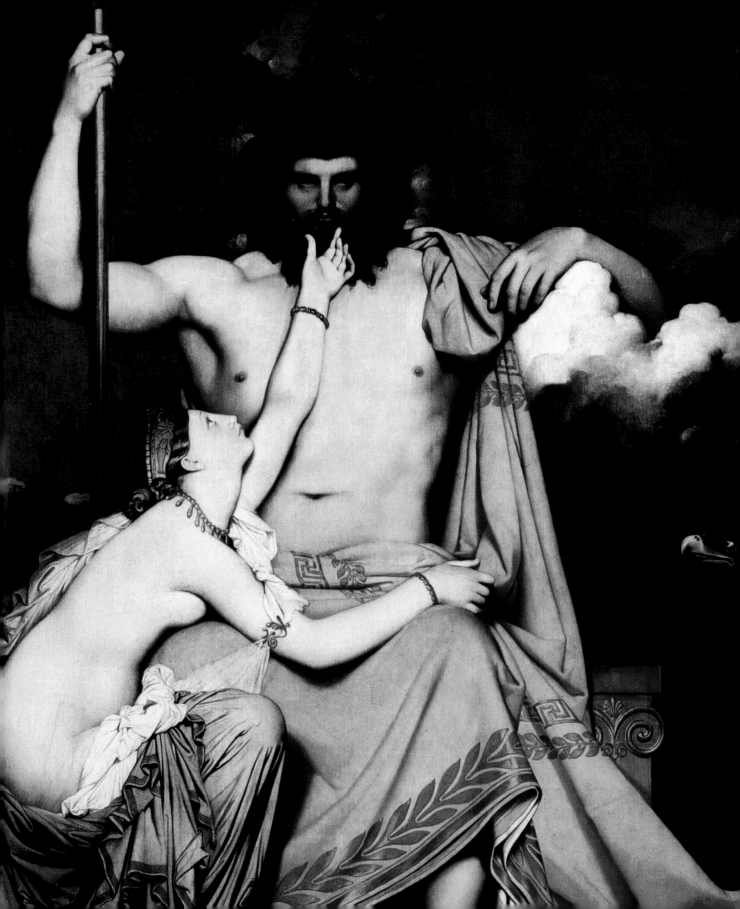

List of Images

List of Vector Images